FLOWERS AND FLYERS

Adult Coloring Book of
Flowers, Songbirds, Hummingbirds,
Butterflies, Owls, Ornamentals and More!

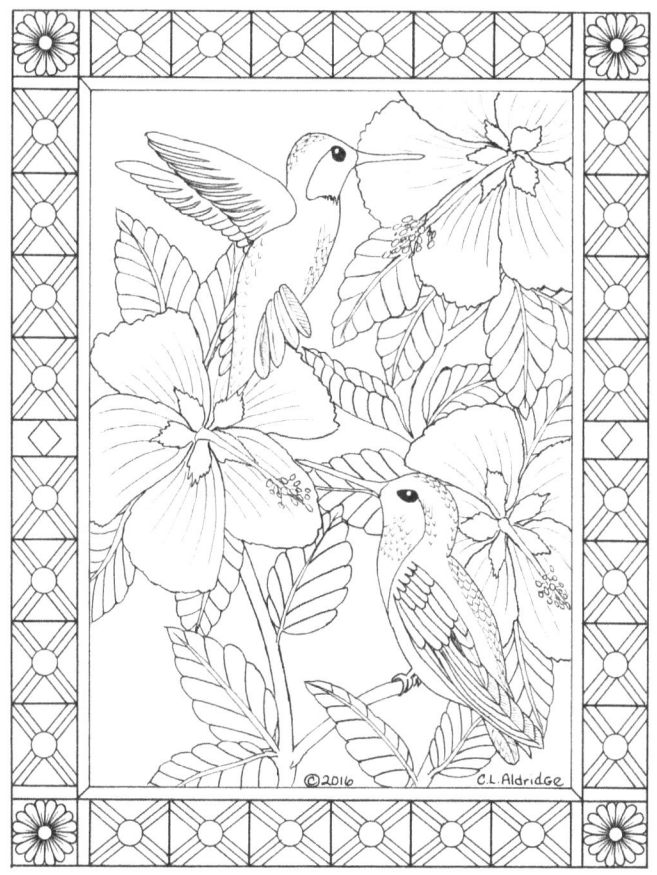

Illustrations by: C. L. Aldridge

Also by C. L. Aldridge

Flowers and Dreams
A Coloring Book of Beautiful Botanical Symmetry

Adult Coloring Book of Flower Inspirations
Beautiful Floral Patterns, Botanical Mandalas,
Gemstones, Lovely Words and More!

- This book is so elegant that when you finish coloring it you want to frame every one! - Jun. 16, 2016 ~ *Amazon Customer*
- Beautiful pictures, expertly drawn... this book is a must for all colorists. I love every single picture in this book - May 6, 2016 ~ *Patti*
- Beautifully drawn pictures to color! C. L. Aldridge has become one of my favorite artists and this is a fabulous book! - April 16, 2016 ~ *Terry K*
- I love this artist and this book has everything I love about her work, and then some! You can't go wrong with Flower Inspirations! - June 7, 2016 ~ *Teresa Z*
- I absolutely love the amazing artwork filling the pages of this Inspirational book! Each unique design can be colored in a multitude of ways. - May 11, 2016 ~ *Sally T*
- C. L. Aldridge has hit it out of the ballpark again! Just as with her first book, "Flowers and Dreams," this one is filled with the most unique and gorgeous floral coloring pages you'll find. Her pages are designed with consideration for any medium you choose to use. I'll be anxiously awaiting the release of a third book! - June 10, 2016 ~ *E. Siegel*

* * * * *

Copyright © 2016 C. L. Aldridge

All rights reserved.

In accordance with the U.S. Copyright Act of 1976, the scanning, uploading, and electronic sharing of any part of this book without the permission of the artist/author constitutes unlawful piracy and theft of the artist/author's intellectual property. If you would like to use material from the book (other than for review purposes), prior written permission must be obtained by contacting the artist/author at:

CLAldridgeArt@gmail.com

Or visit me on Facebook at: www.facebook.com/CLAldridgeArt
Or visit my website at: www.CLAldridgeArt.com
Or follow me on Instagram: @CLAldridgeArt

Thank You for your support of the artist/author's rights.

ISBN: 10: 1537199684
ISBN-13: 978-1537199689

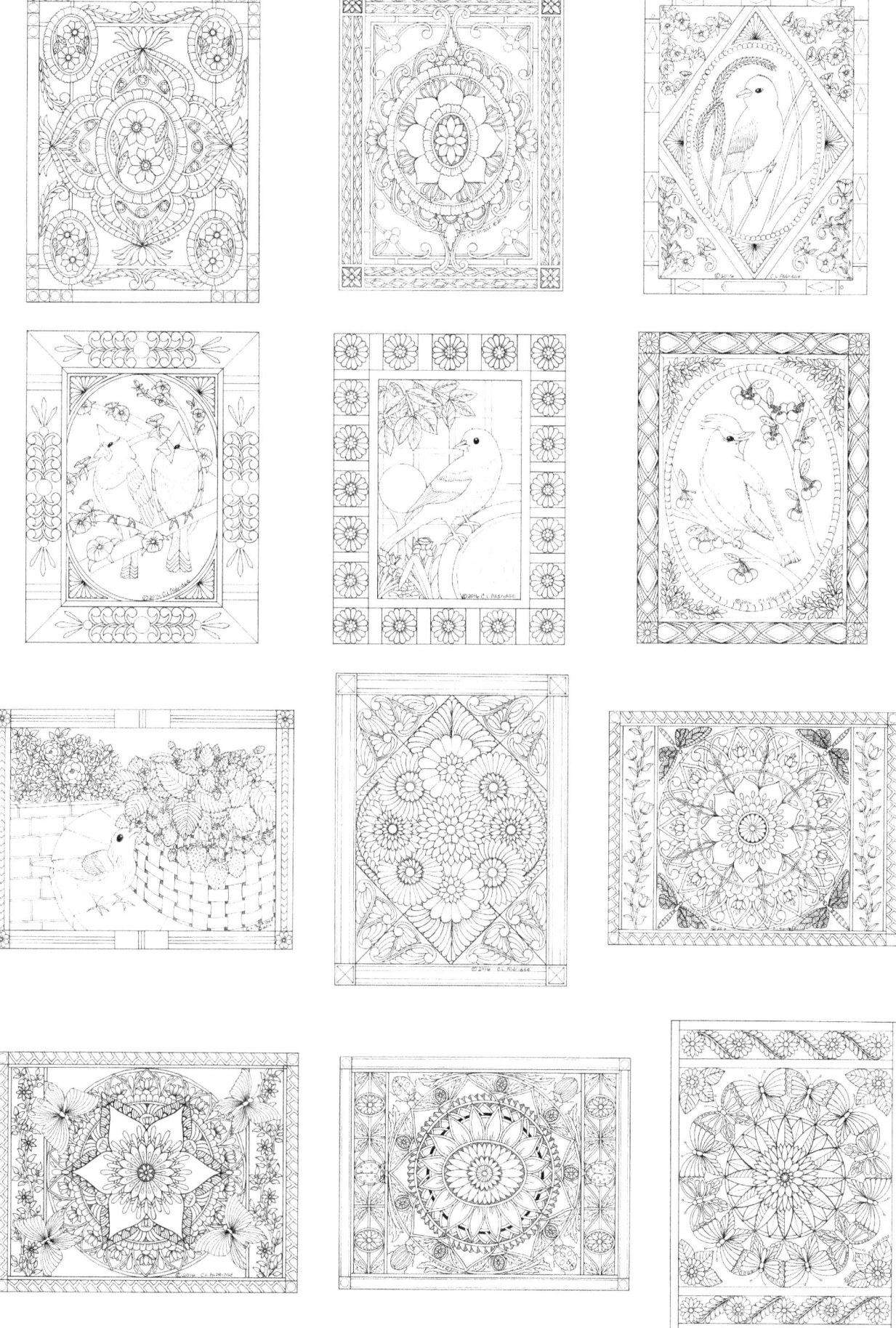

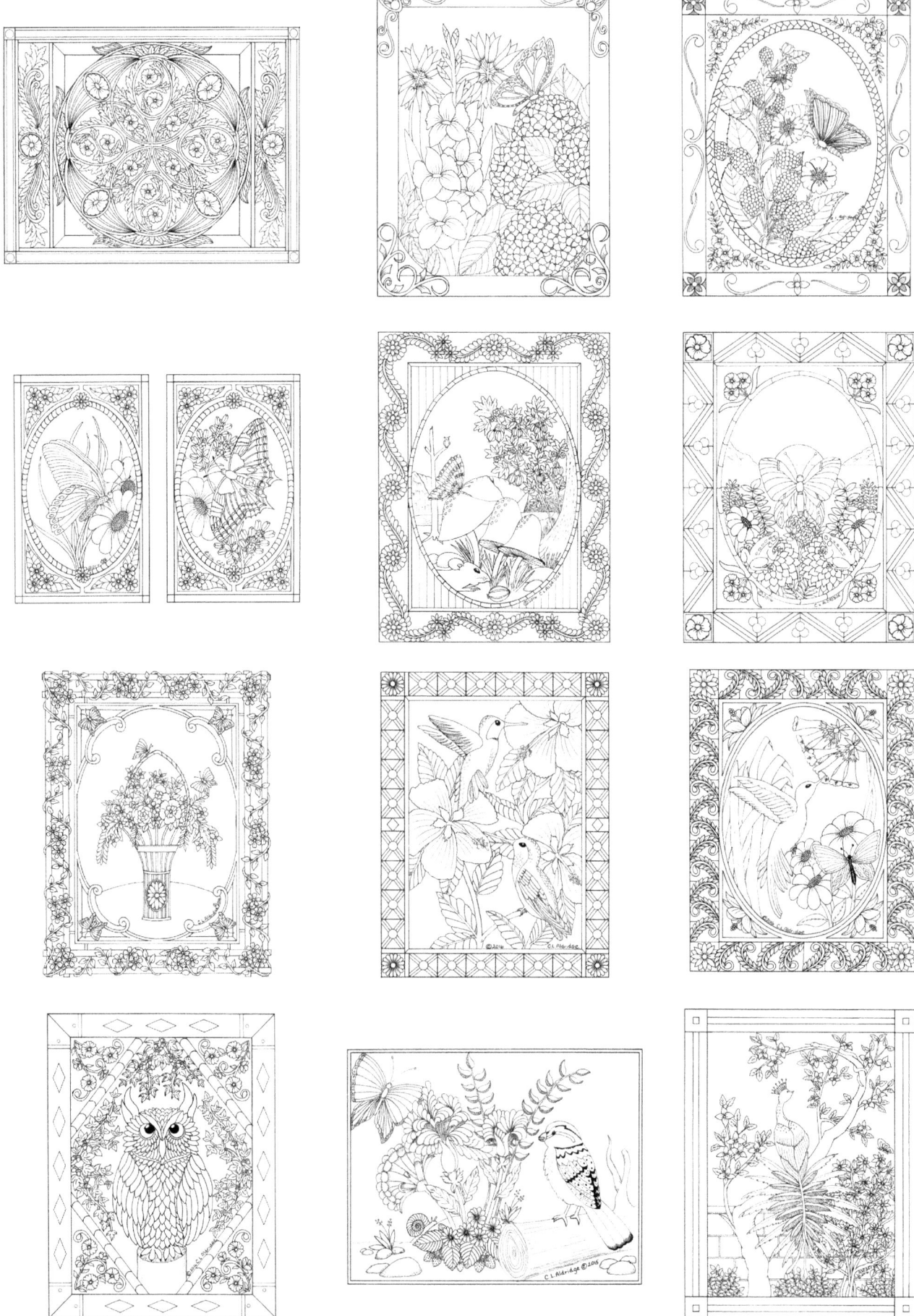

For all the colorists across the world that have encouraged me to keep drawing each and every day; and upon learning of a third book underway urged me to please hurry, this one is for you! I hope you enjoy it as much as I enjoyed drawing it for you.

A very special thank you to colorists: Susan Curry Virginia Sanders Cole, Elizabeth Zack Siegel, and Lisa Johnson for so generously allowing me to use their colored renderings of my drawings on the cover of this book.

* * * *

IMPORTANT INFORMATION FOR USING THIS BOOK

- This book contains 24 hand-drawn illustrations, SINGLE SIDED (back is blank).

- Each illustration is printed in TWO SIZES, a full size page and a crafters size (suitable for a 5" x 7" frame, mounting to a greeting card face or scrapbook page, etc). Please note the crafters sizes are also single sided and are printed two on a page.

- The pages are printed on #60 lb bright white paper which performs well for all brands of colored pencils and crayons, without the need of a blotter page.

- To avoid any "Uh Oh's" and the associated disappointment, **Marker and Gel Pen users are STRONGLY ENCOURAGED to USE A BLOTTER SHEET** behind the drawing to avoid any possibility of bleed through to the next page. Several blank blotter and color testing pages are provided at the end of this book.

- Most IMPORTANT of all: Relax, have fun, stand-up and stretch often, and remember that sometimes the most beautiful things come from what we think at first are mistakes, but which turn out to be art's way of working magic!

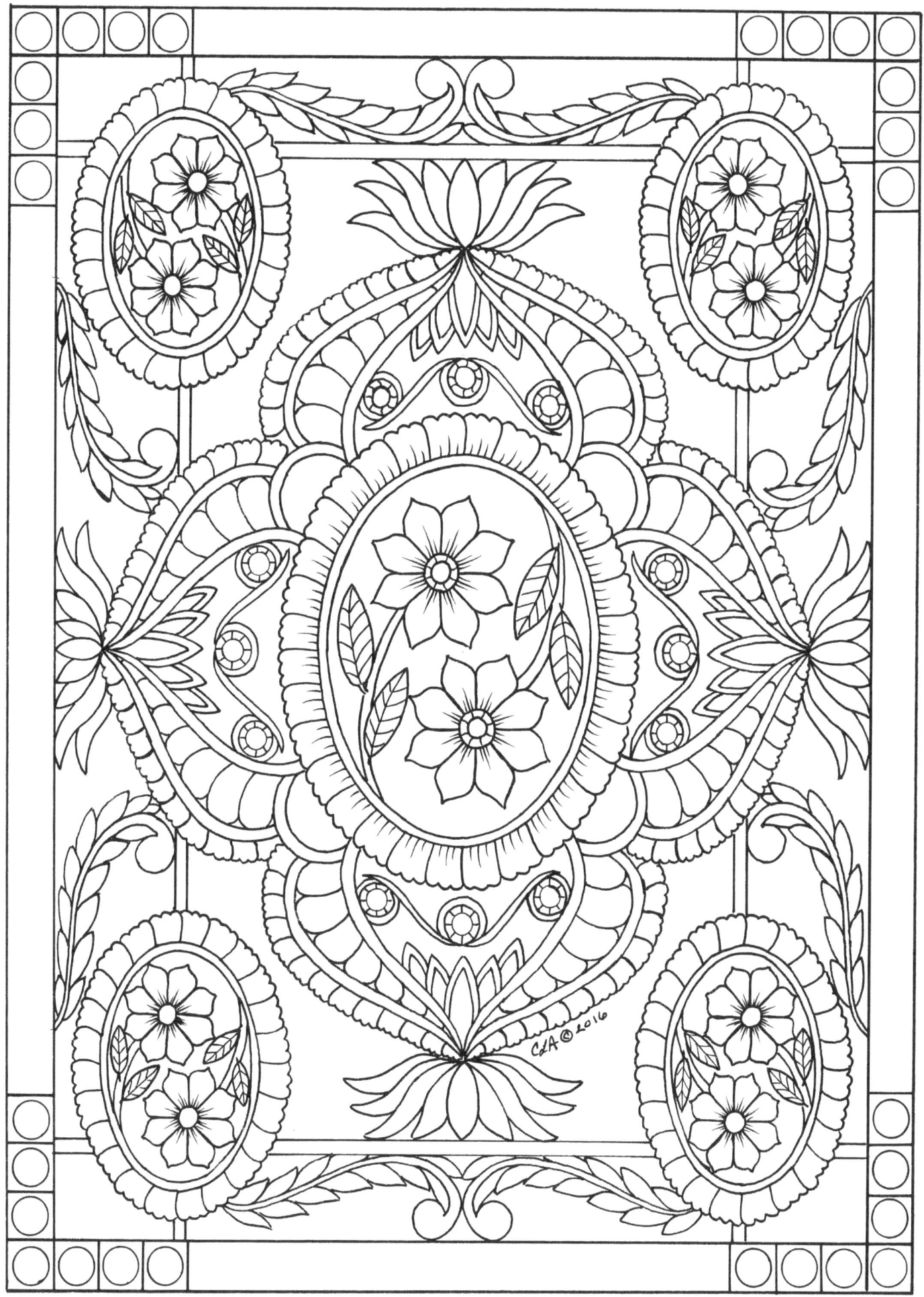

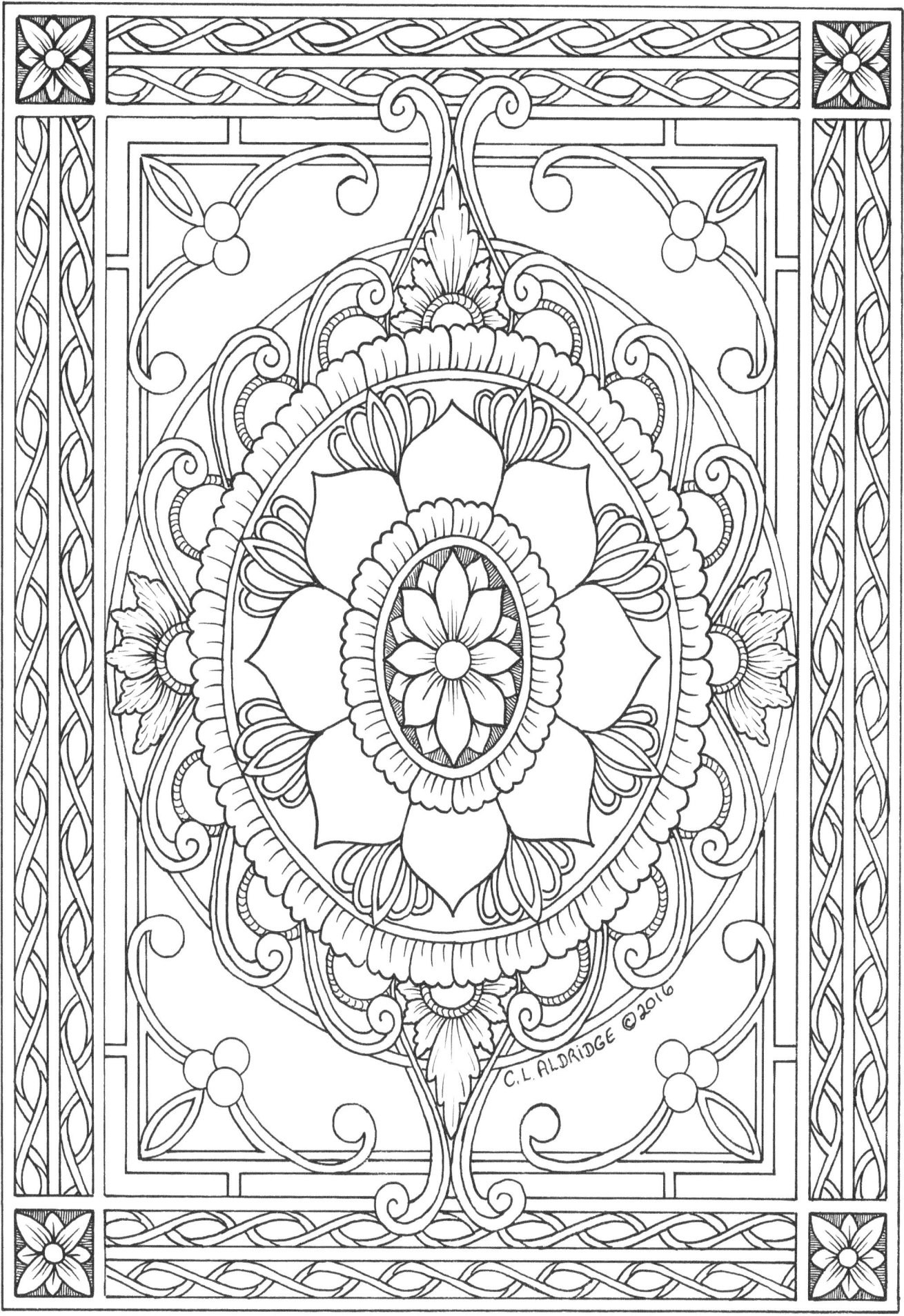

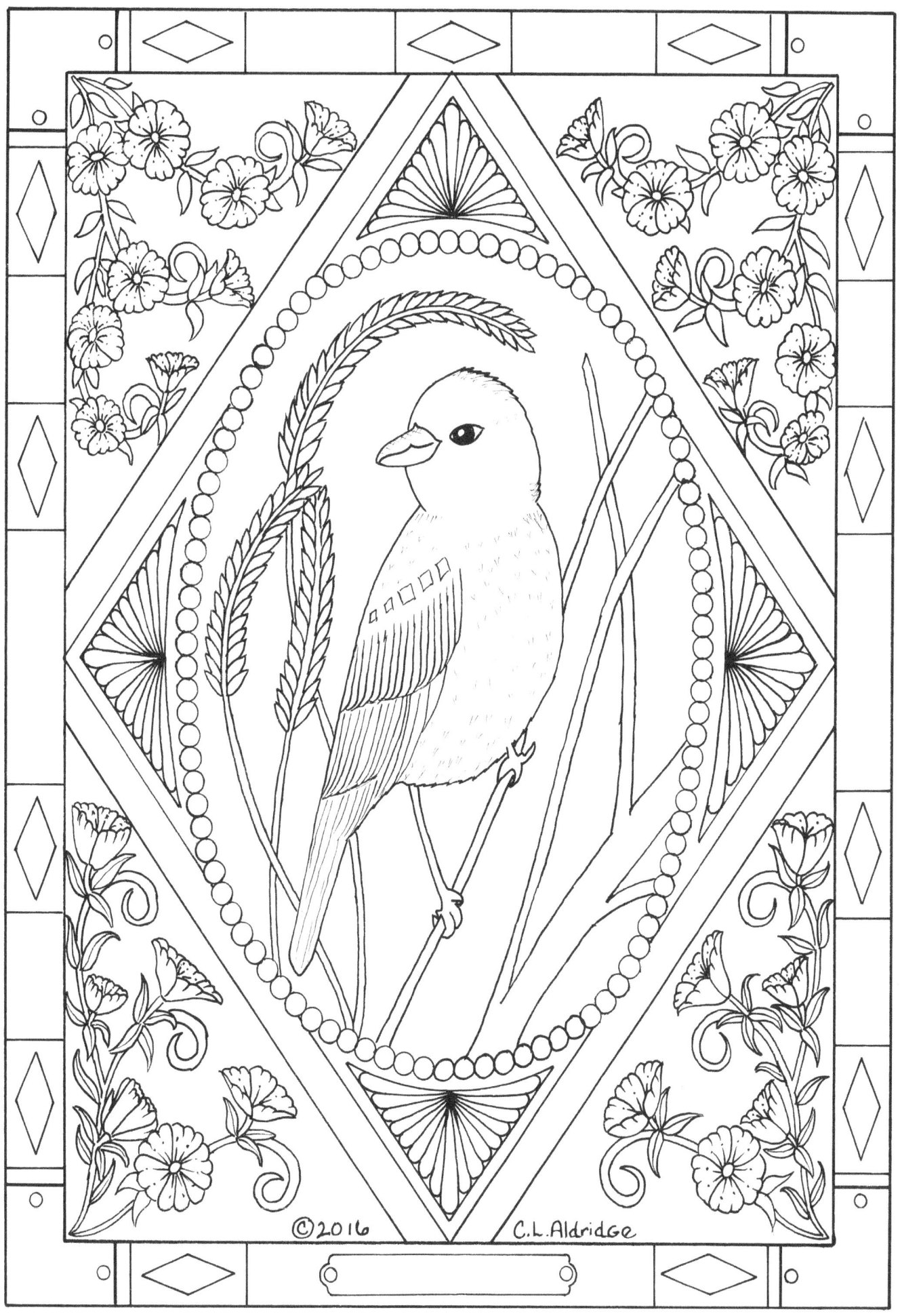

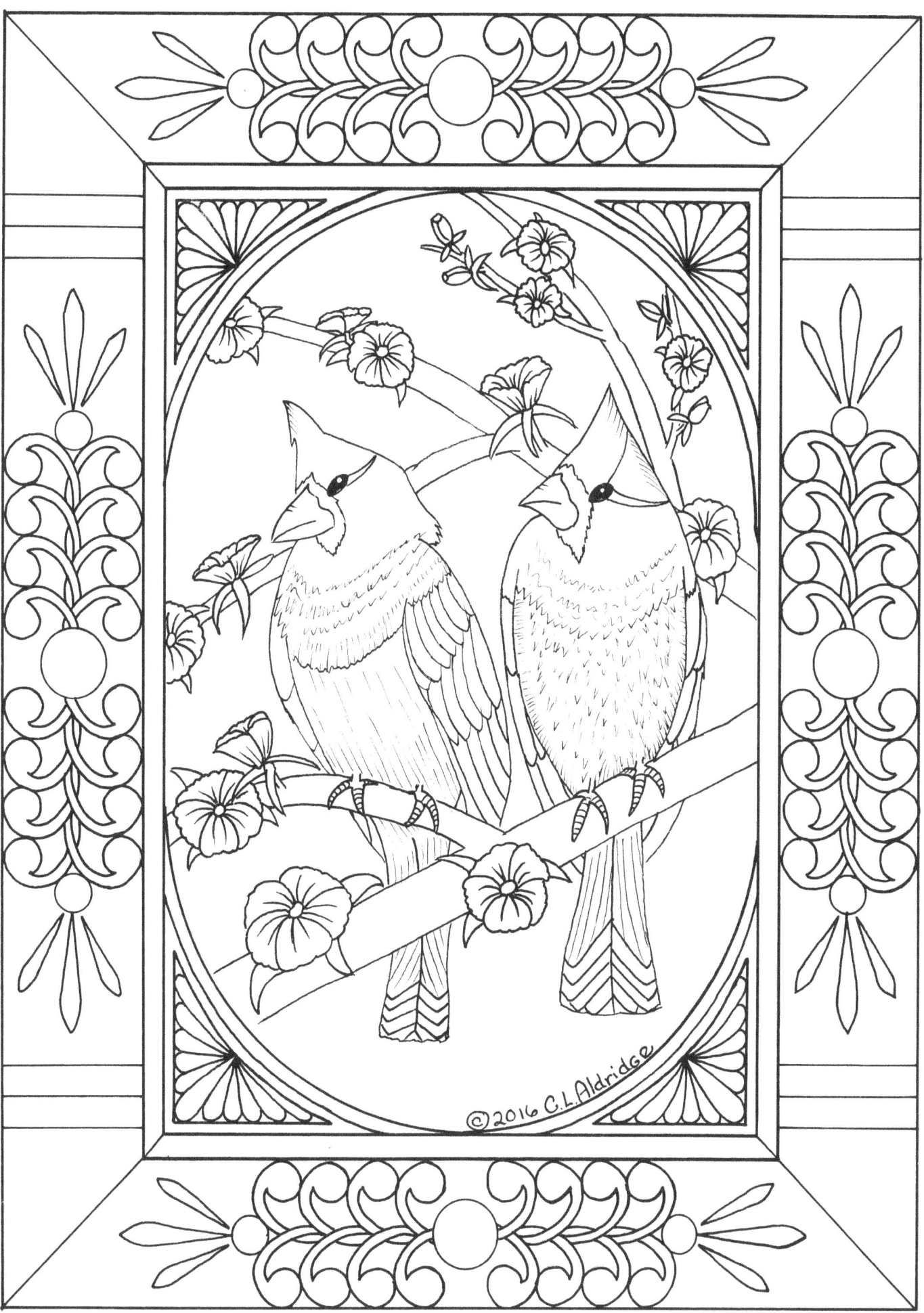

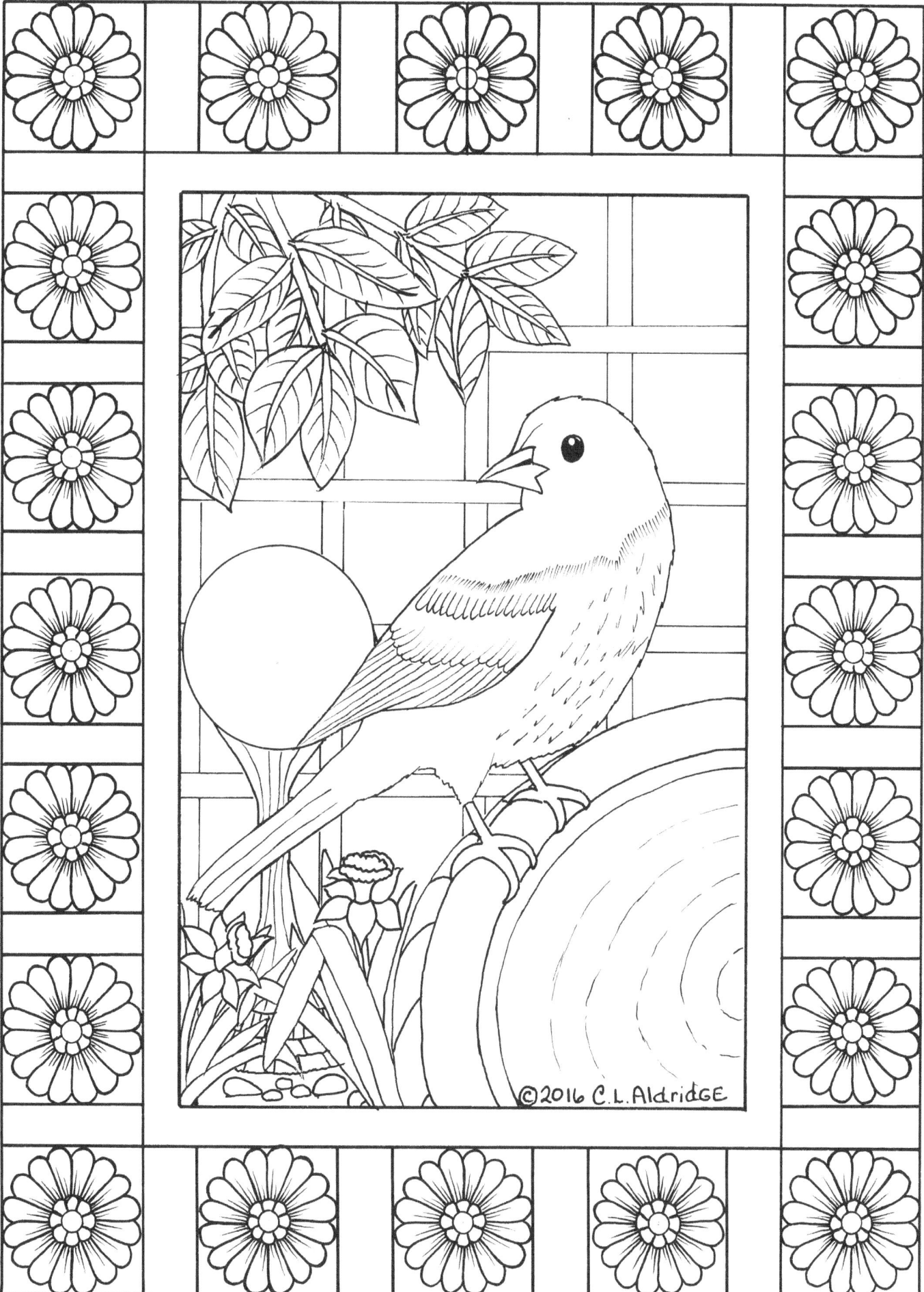

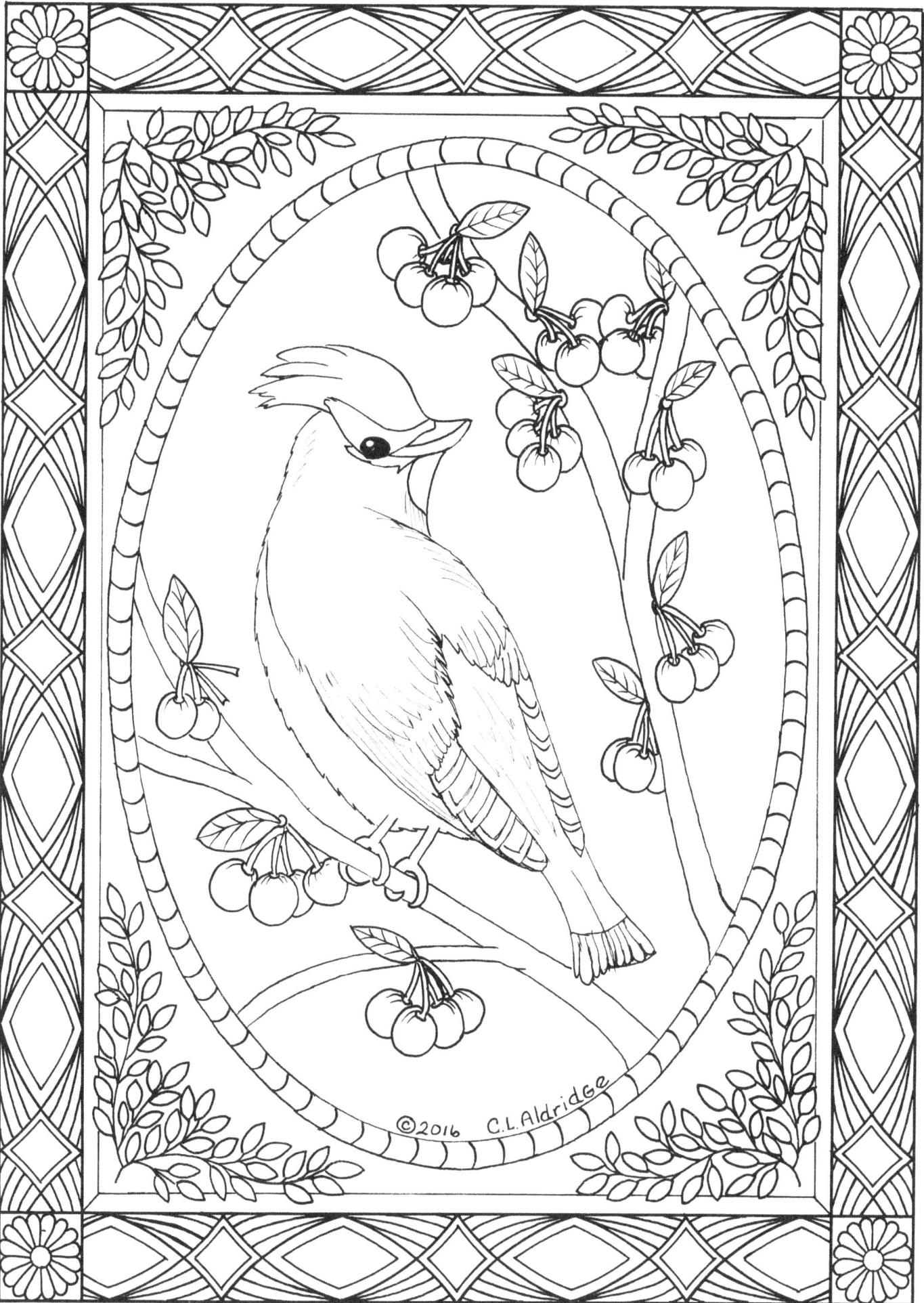

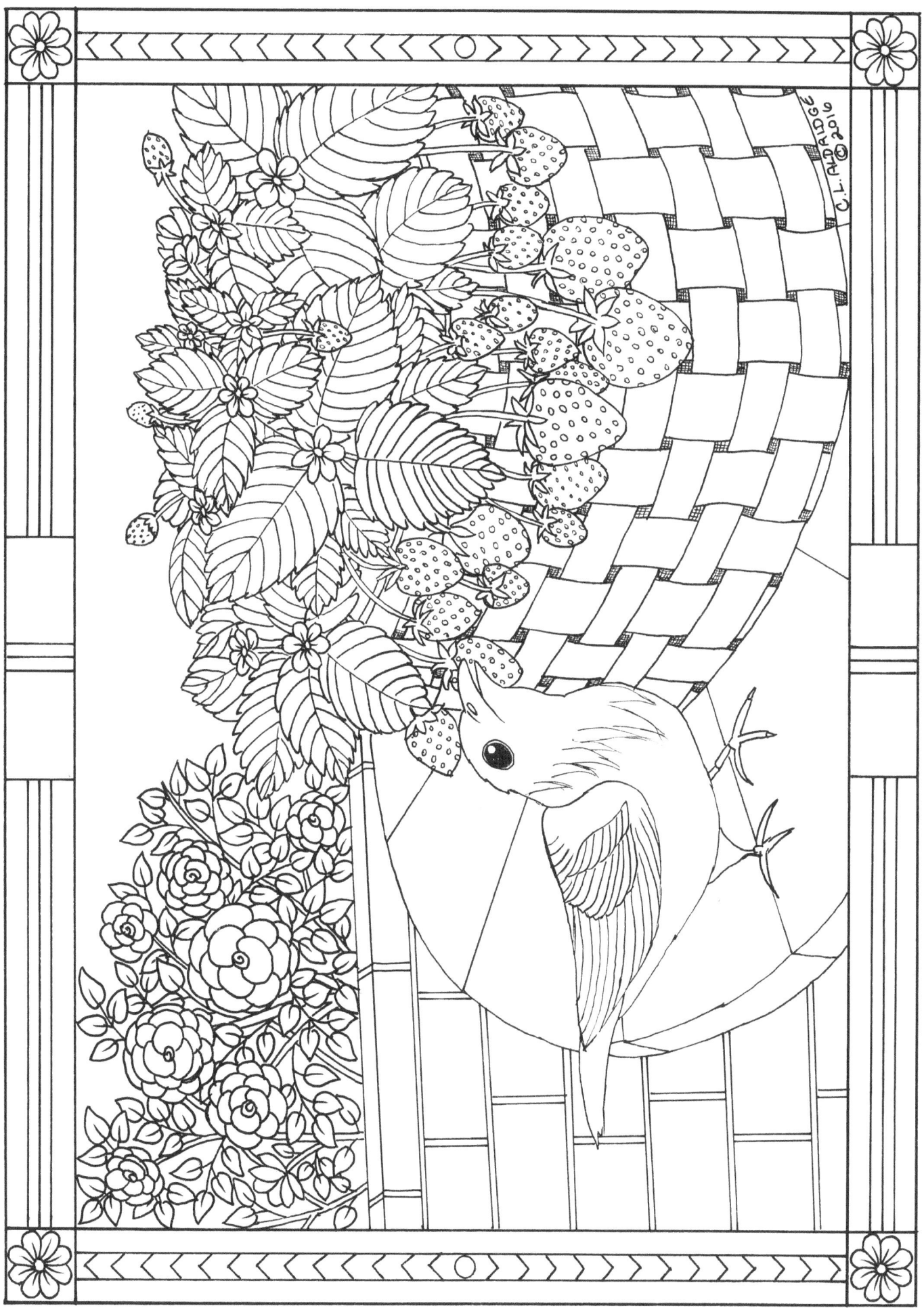

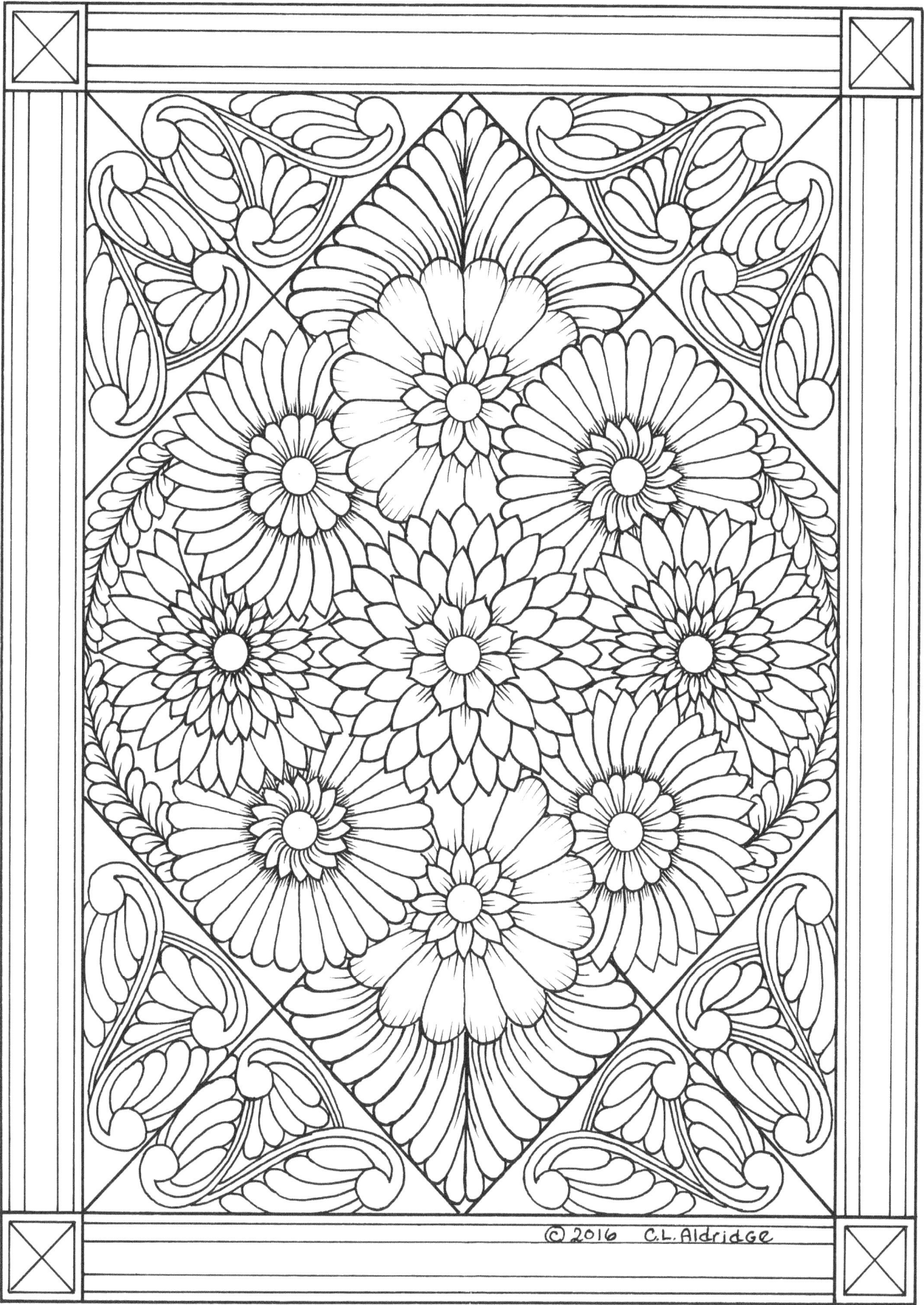

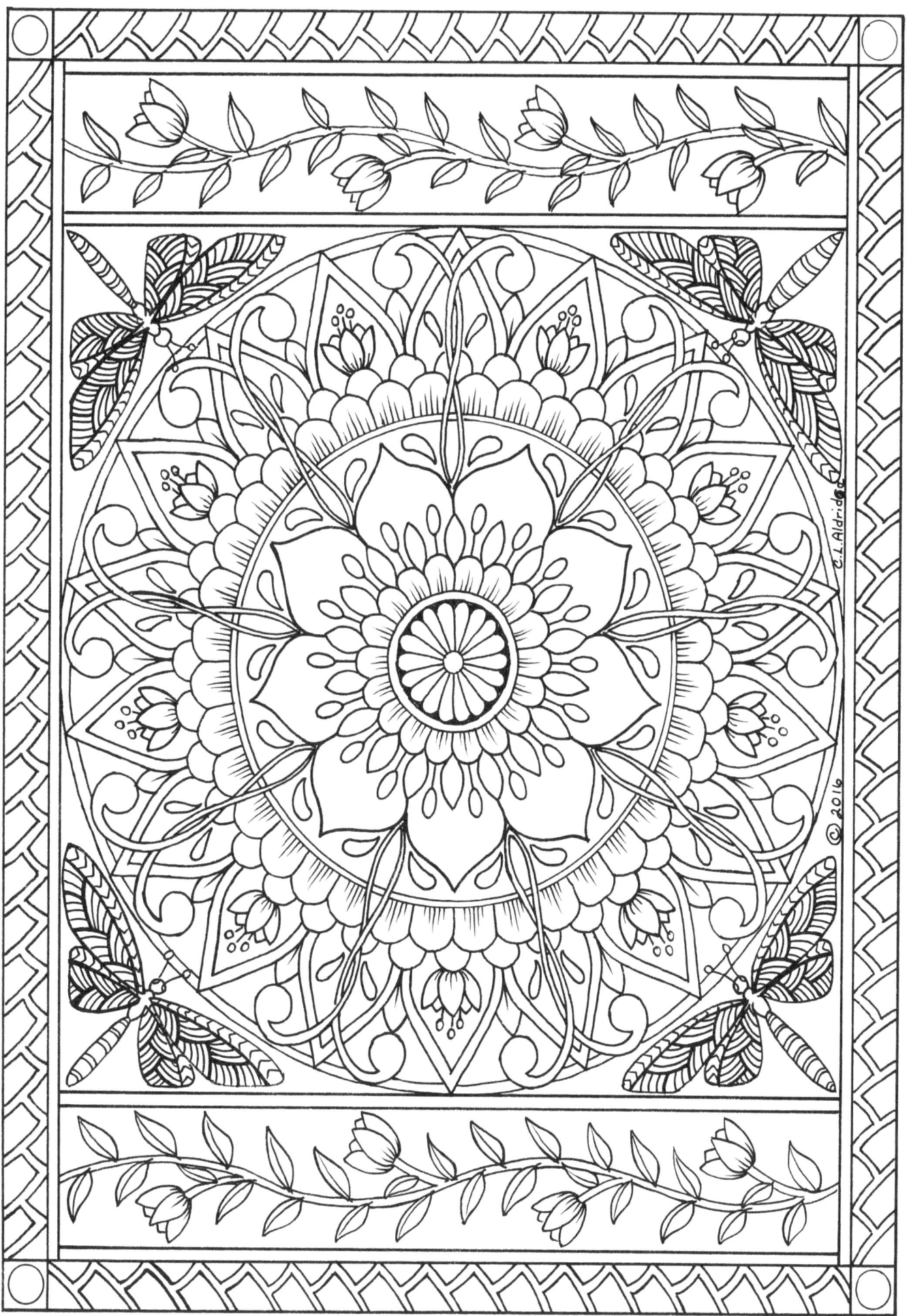

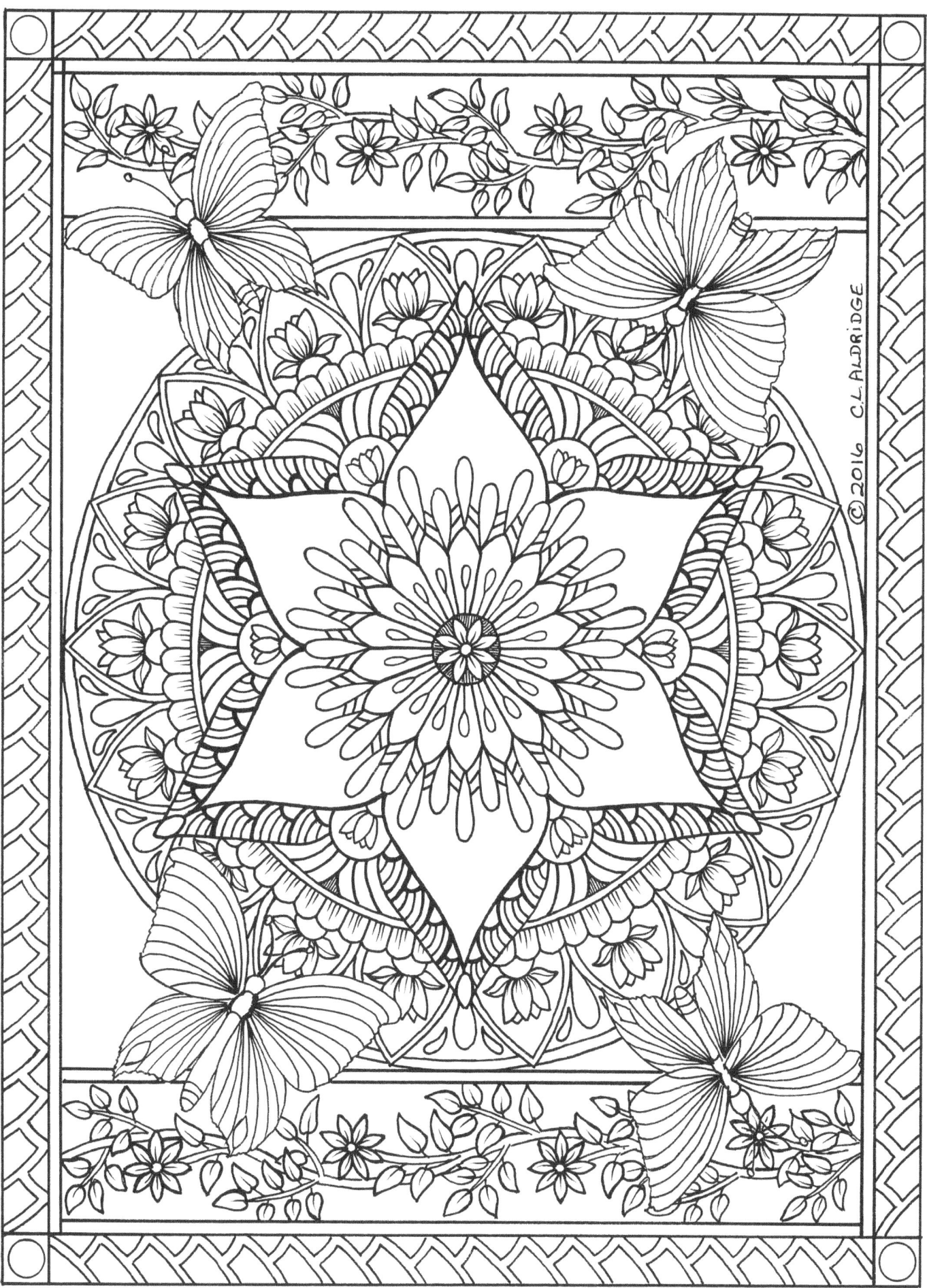

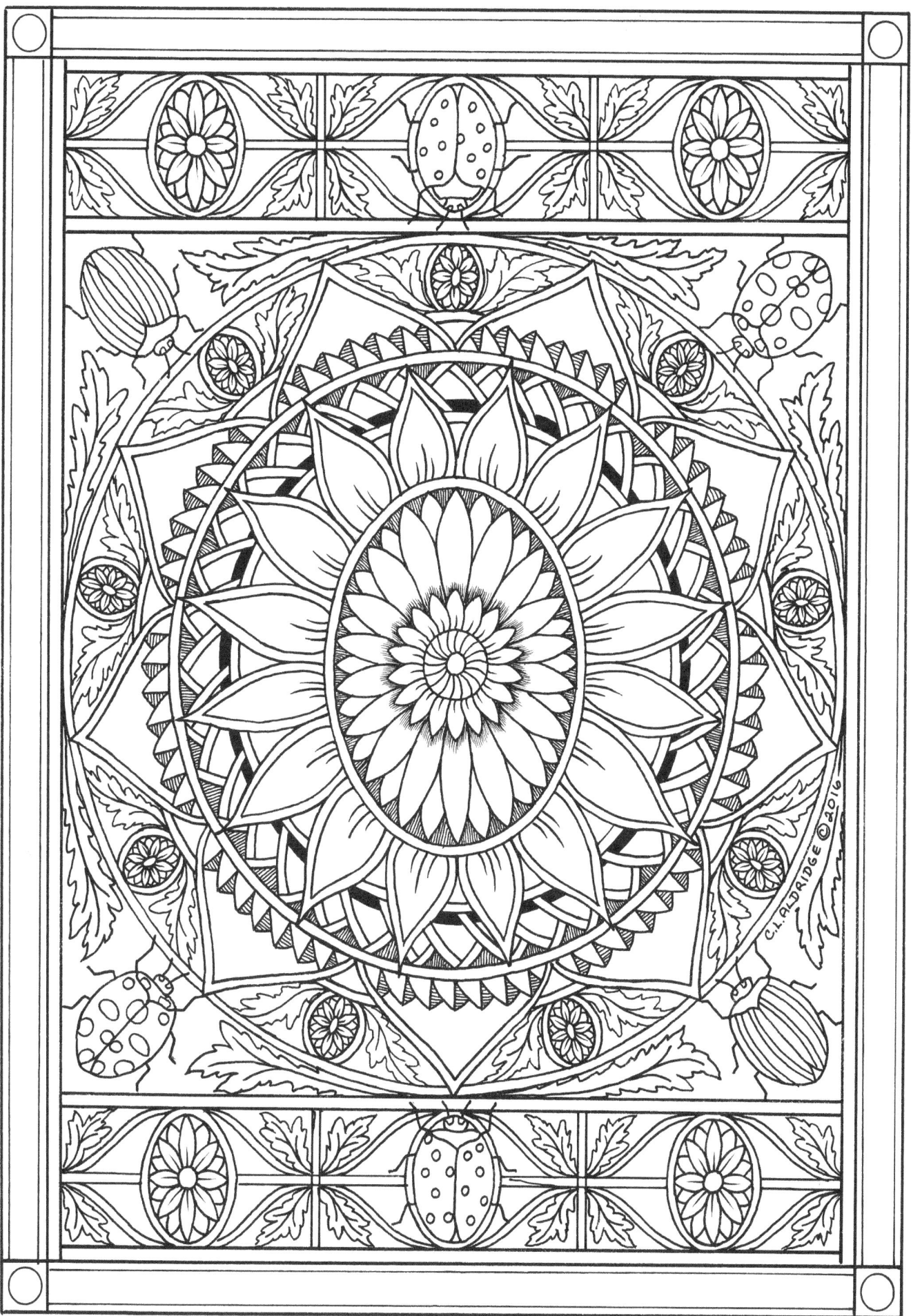

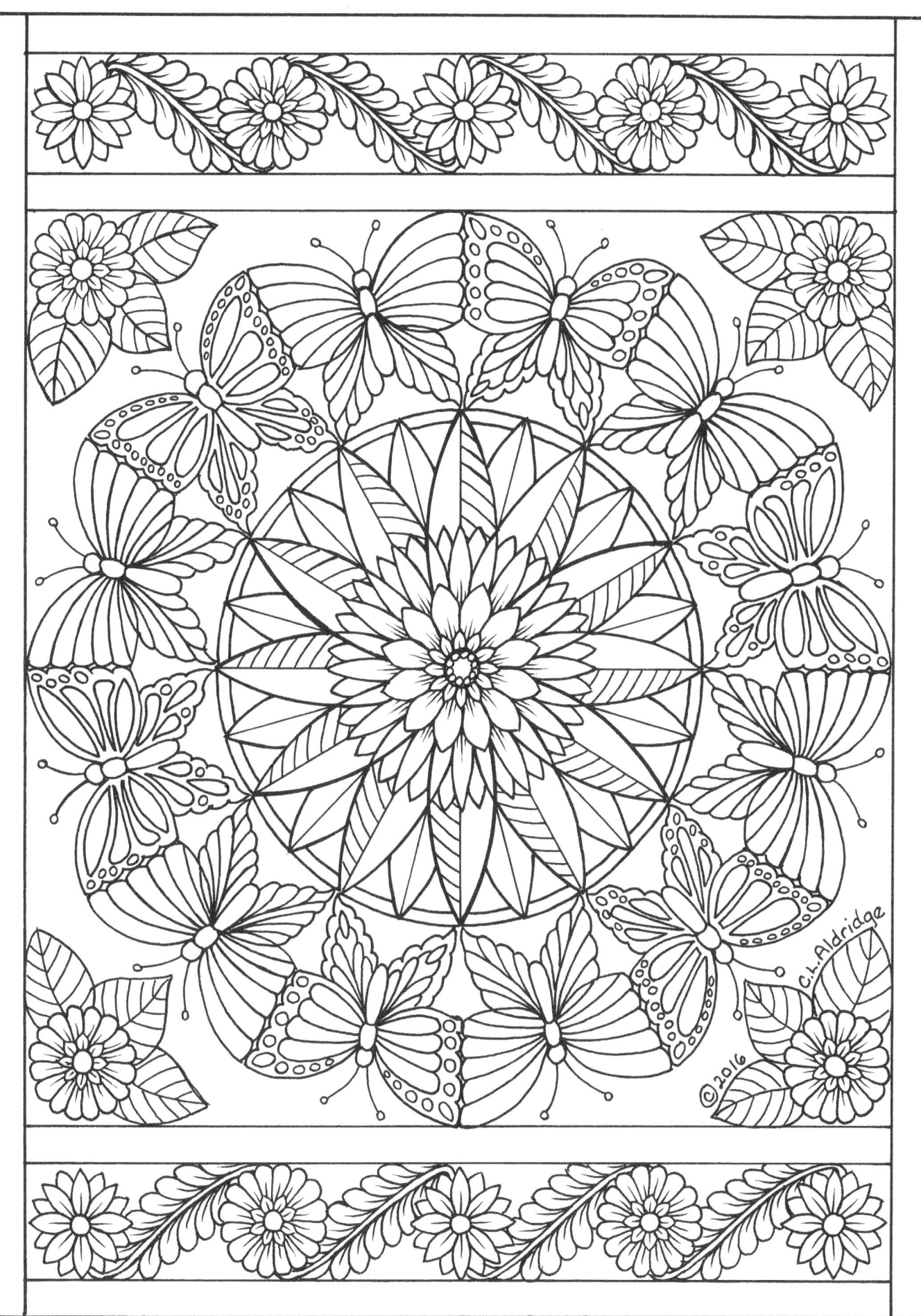

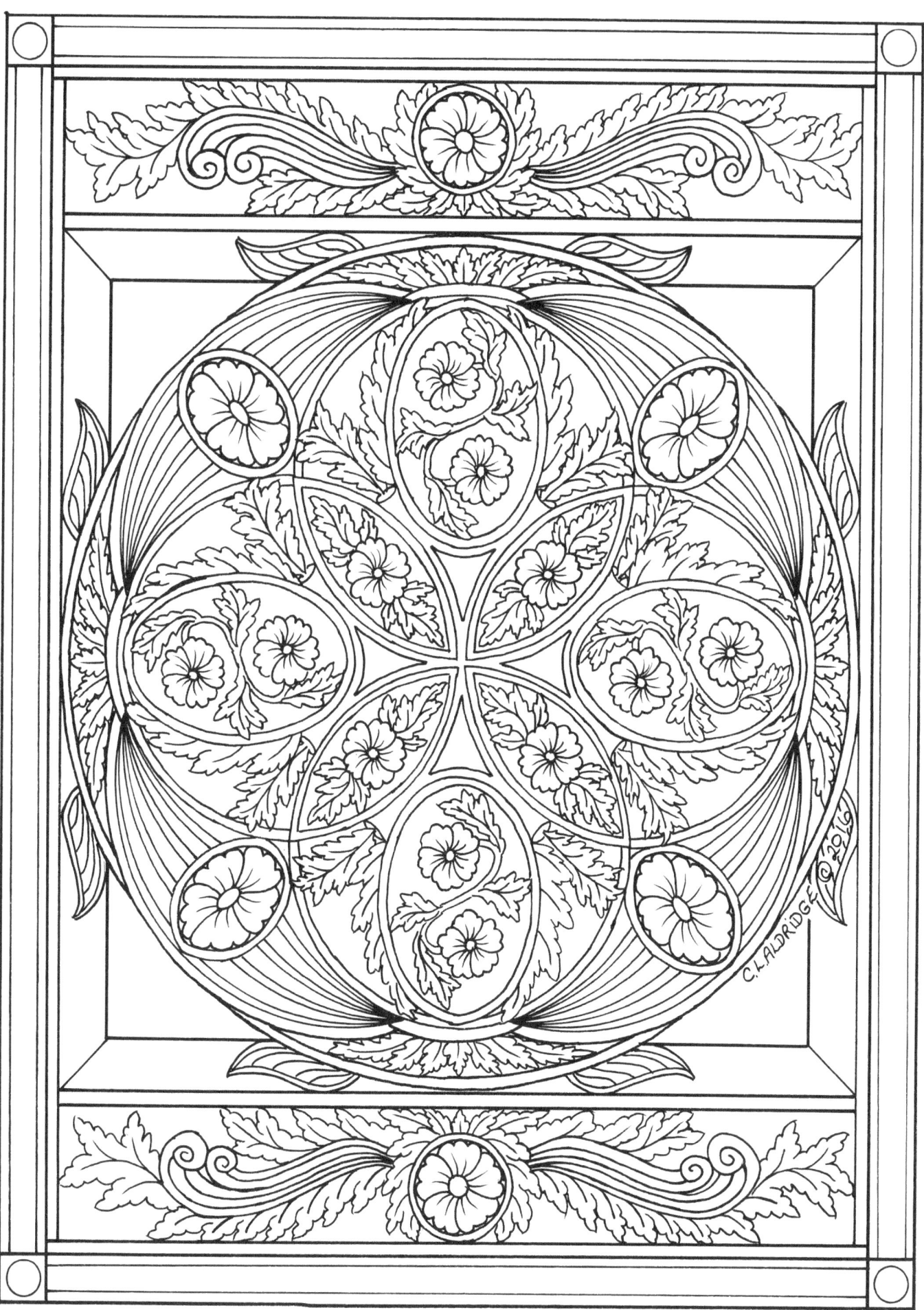

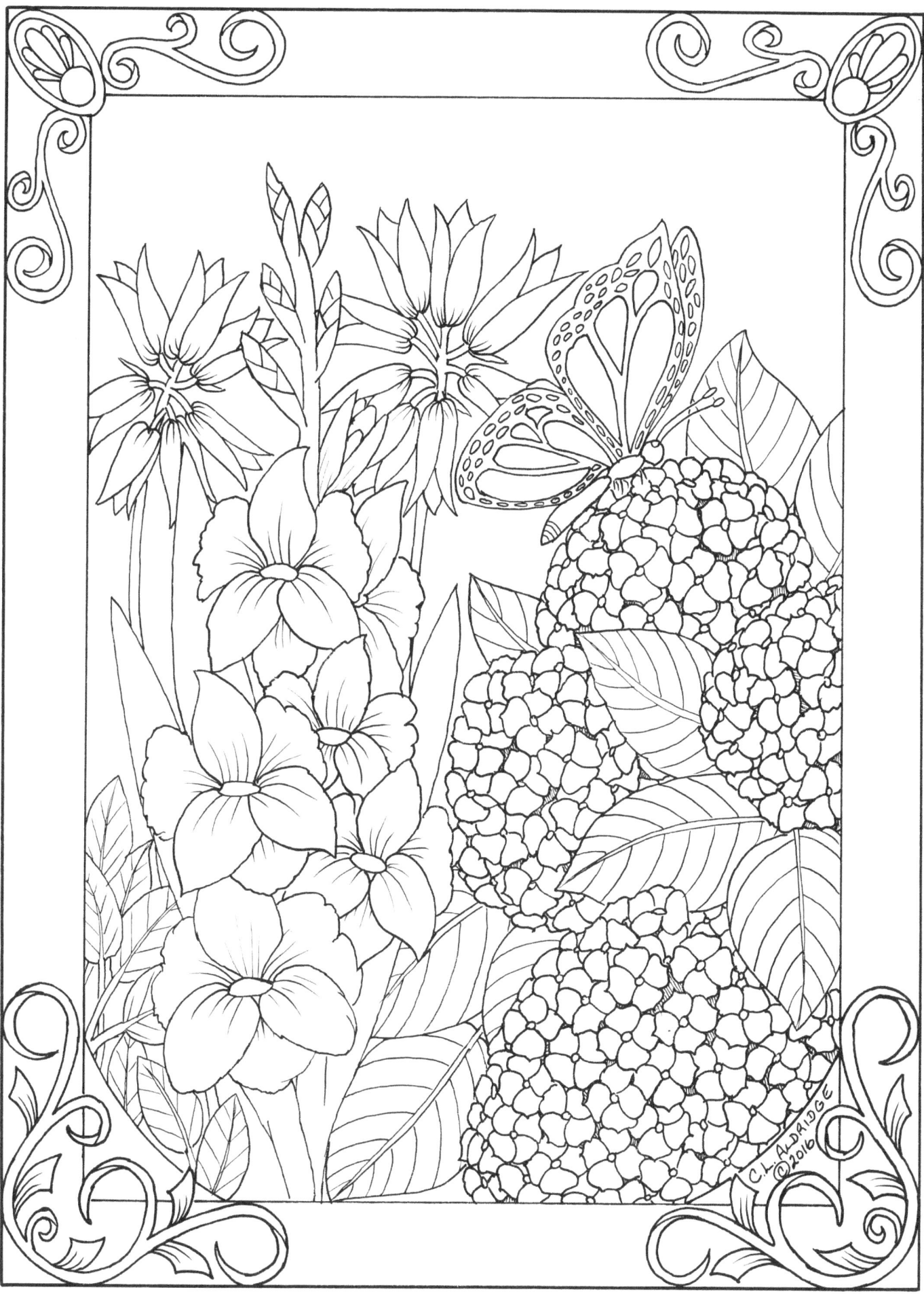

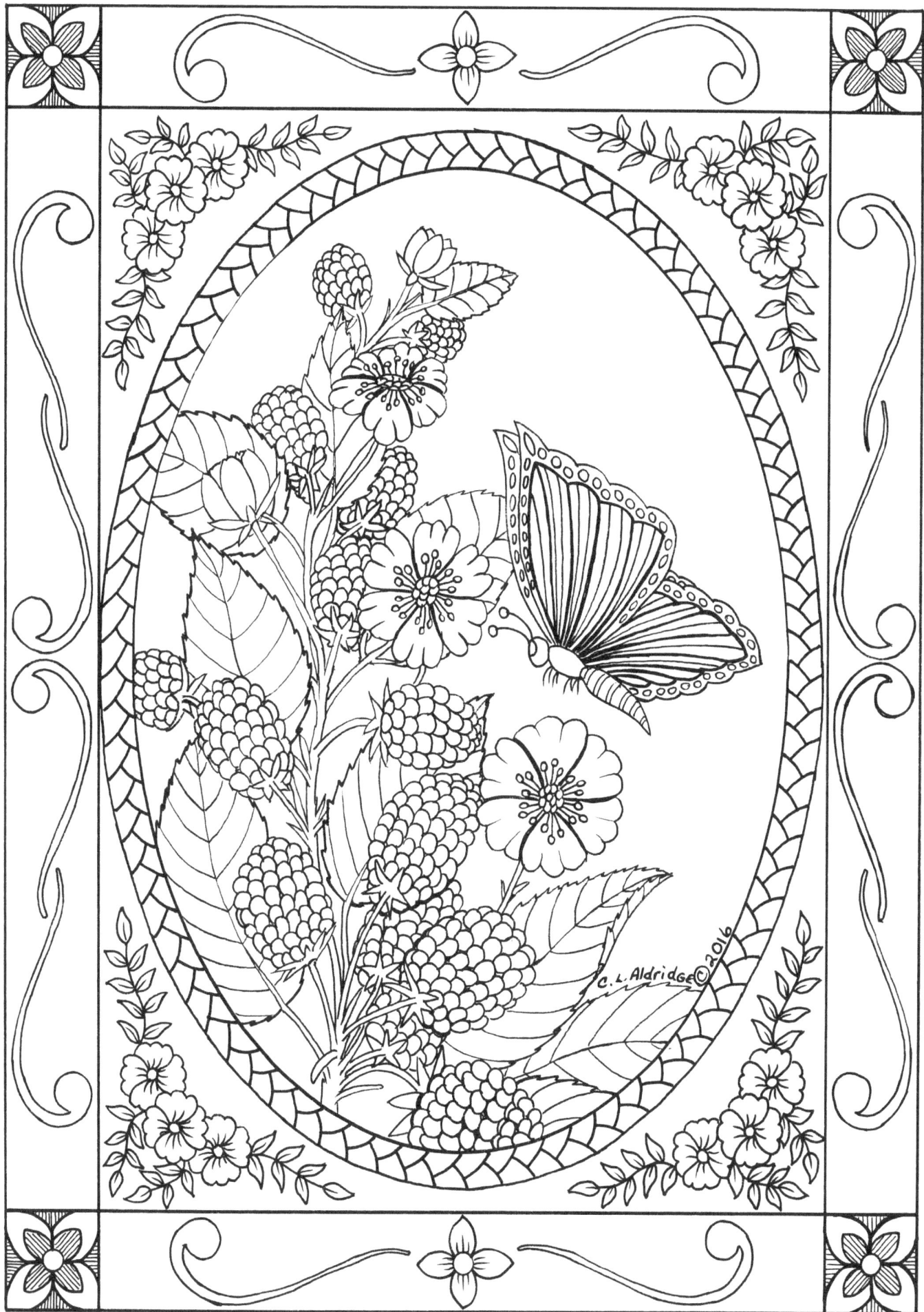

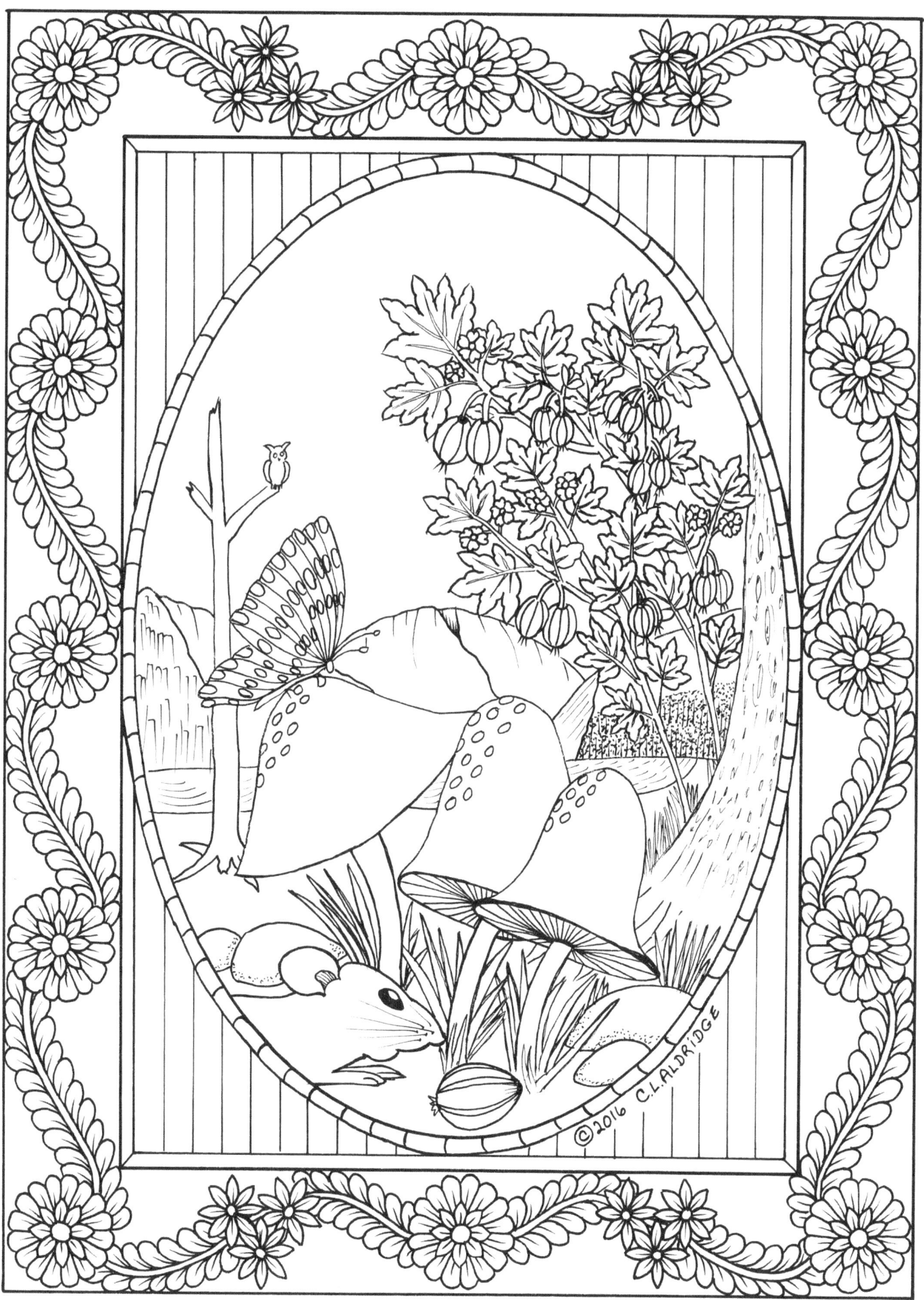

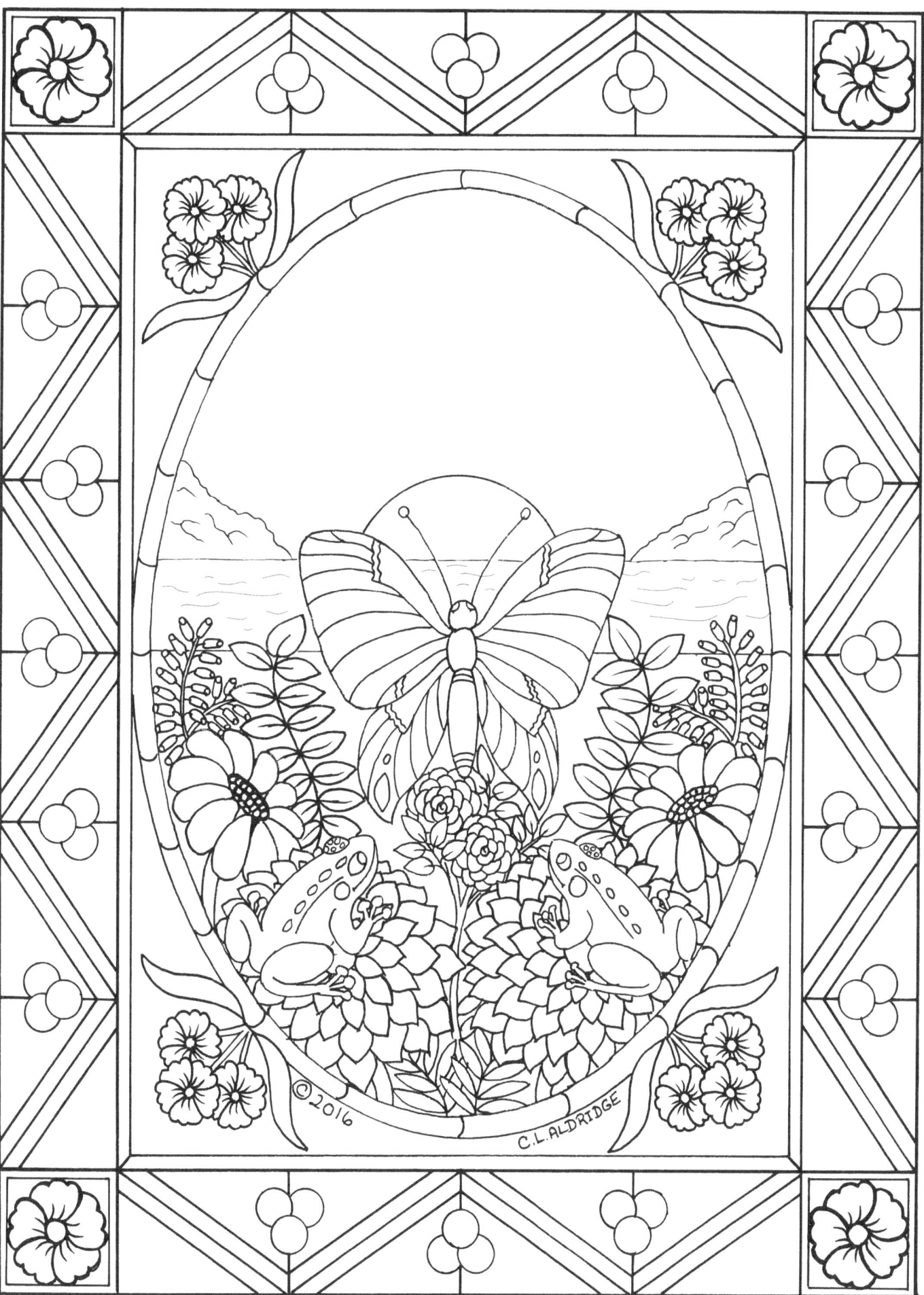

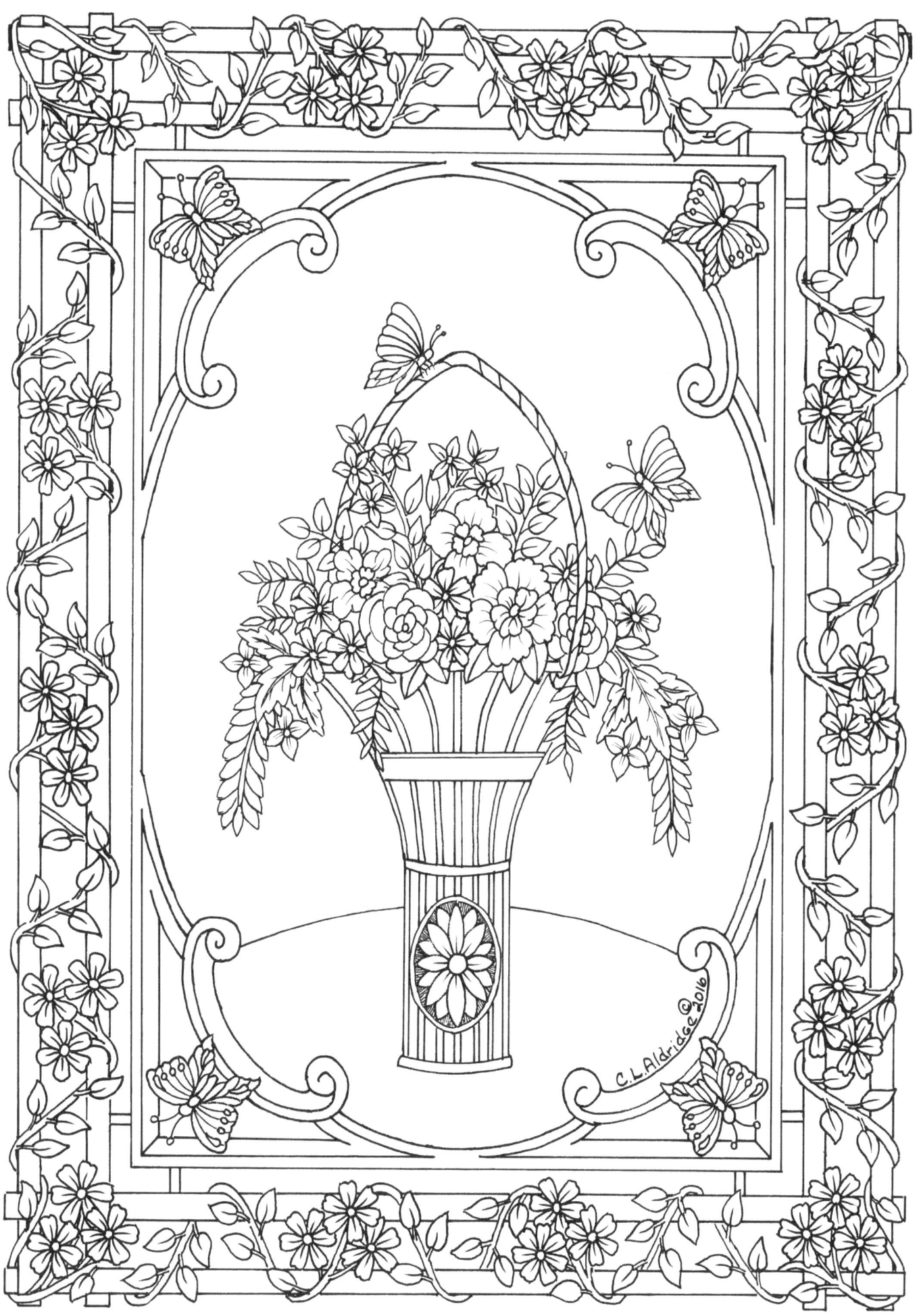

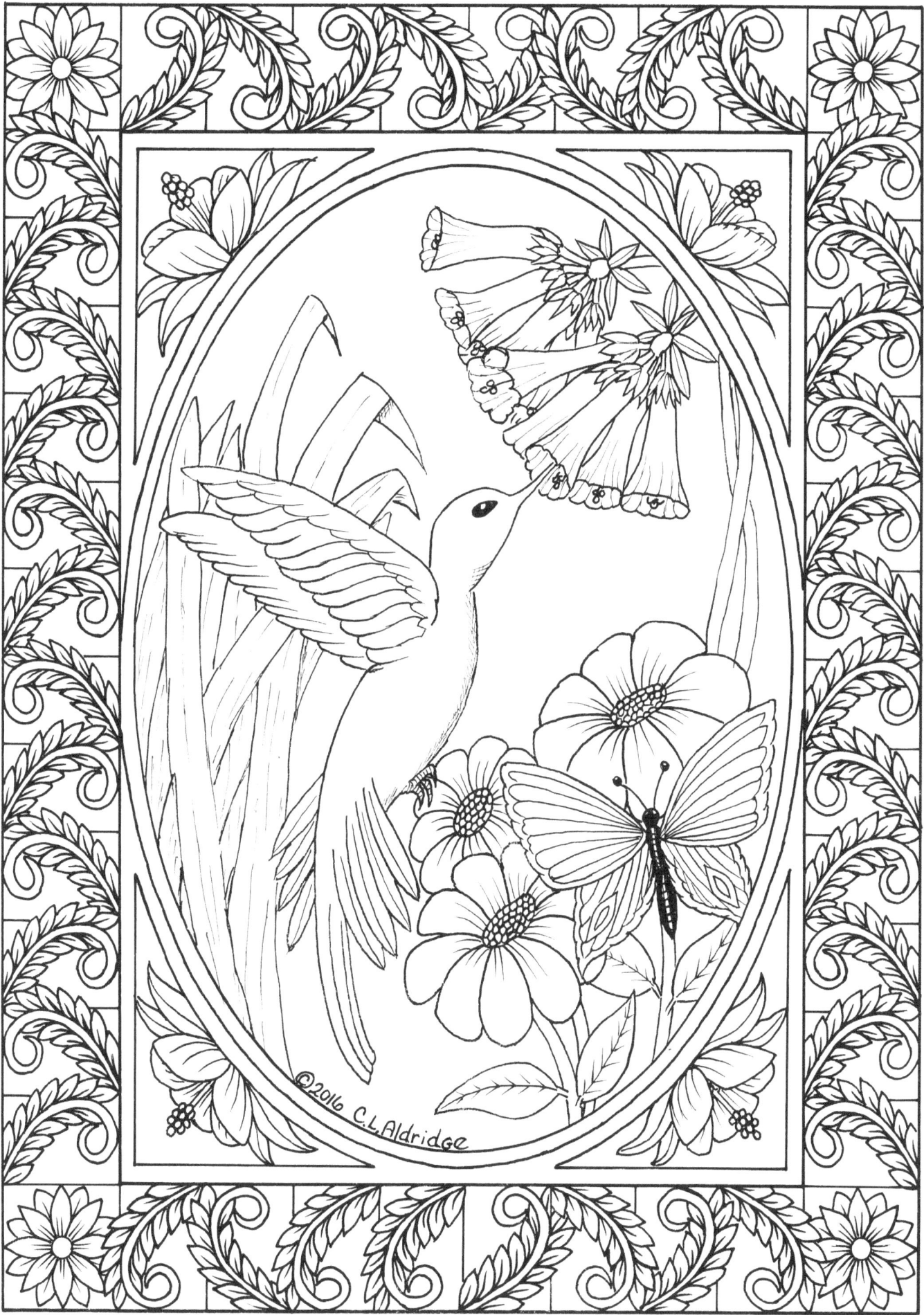

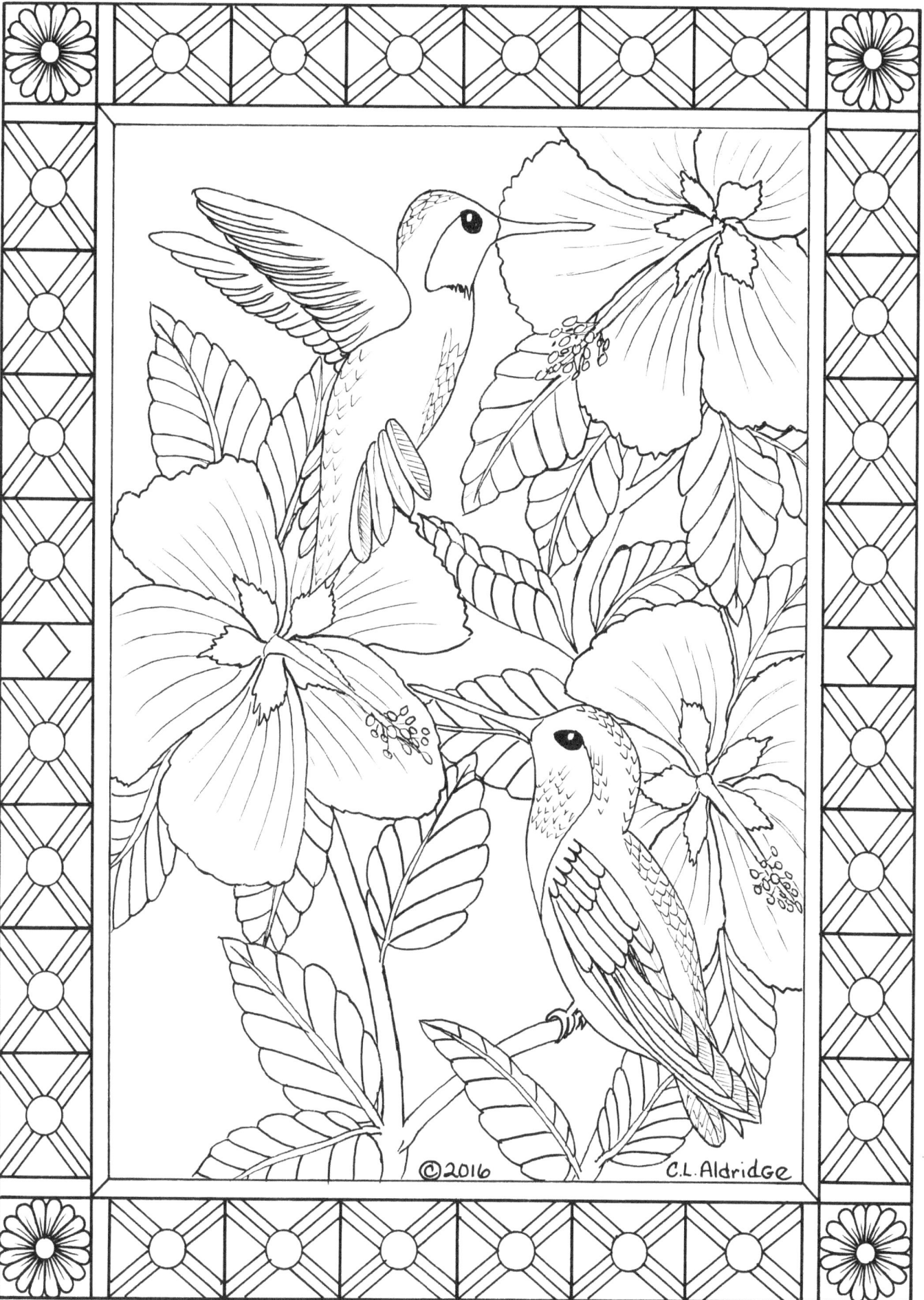

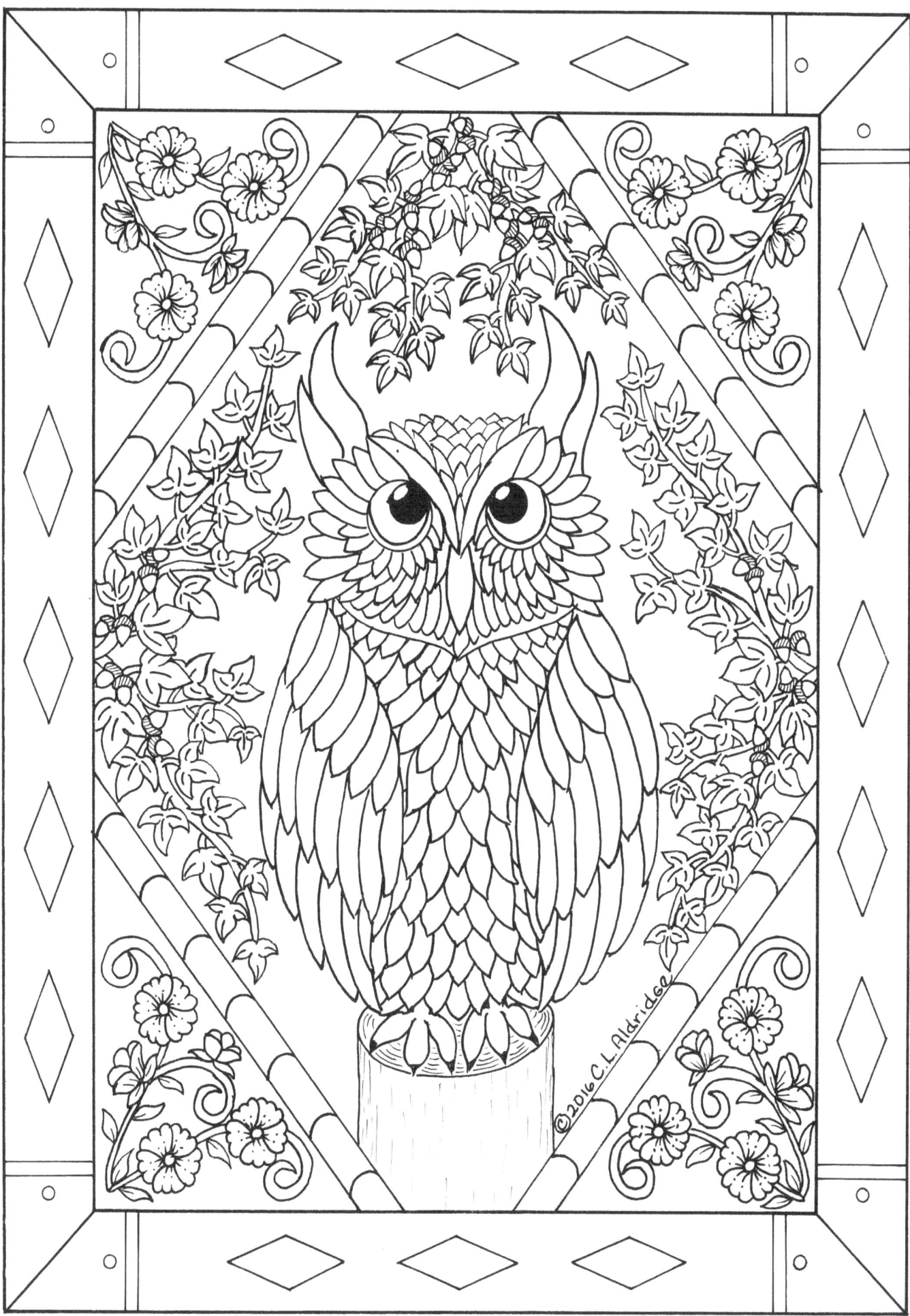

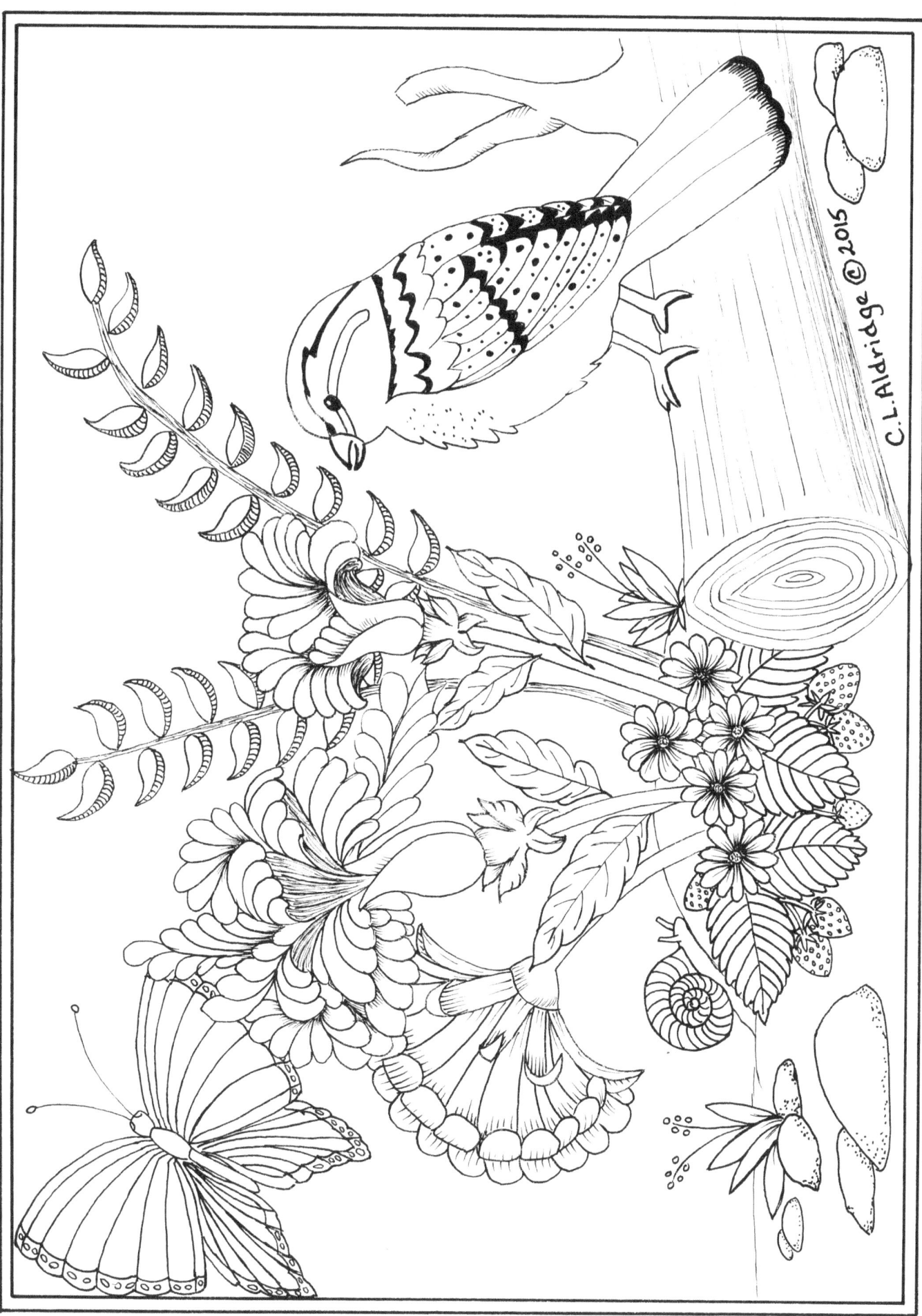

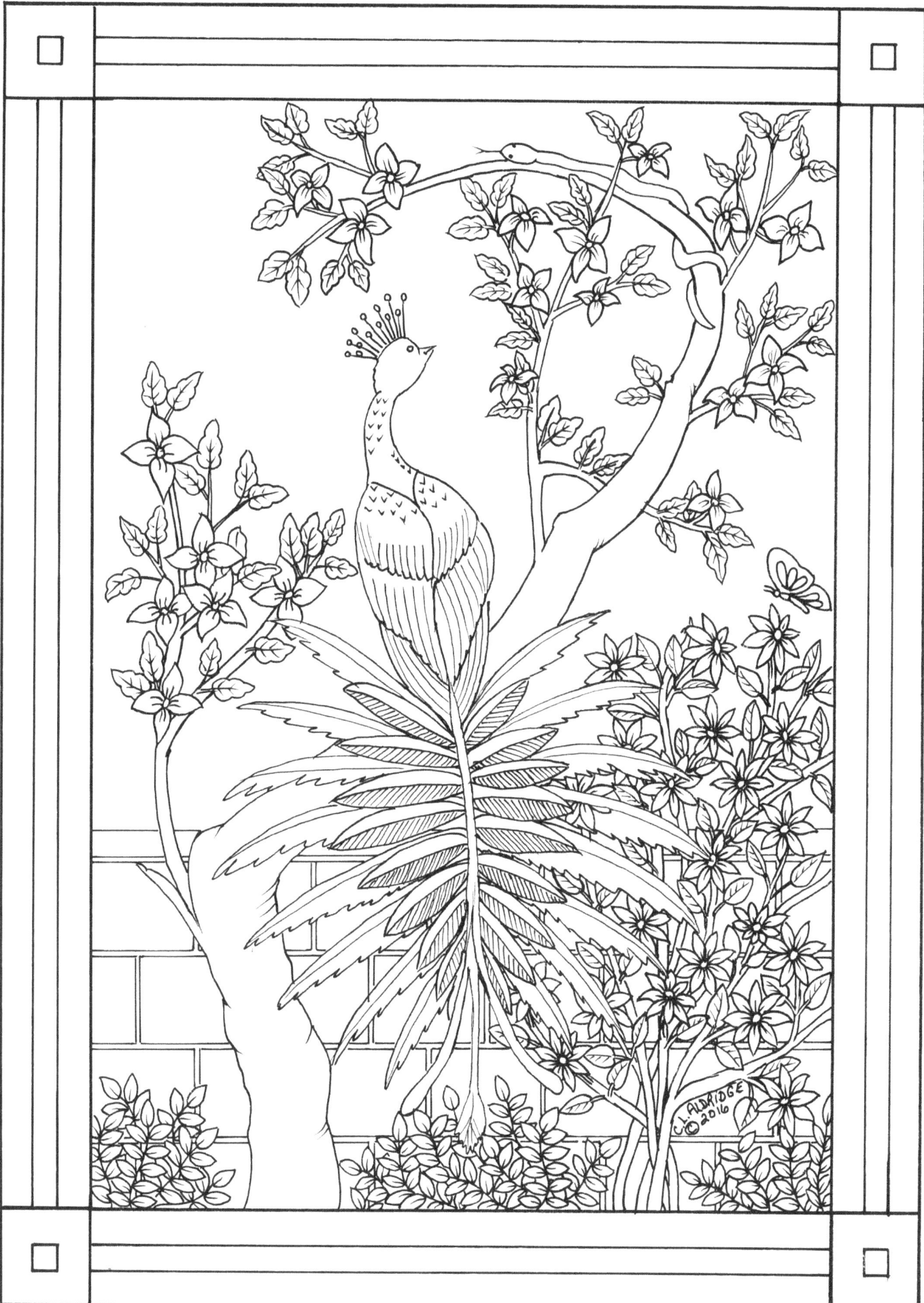

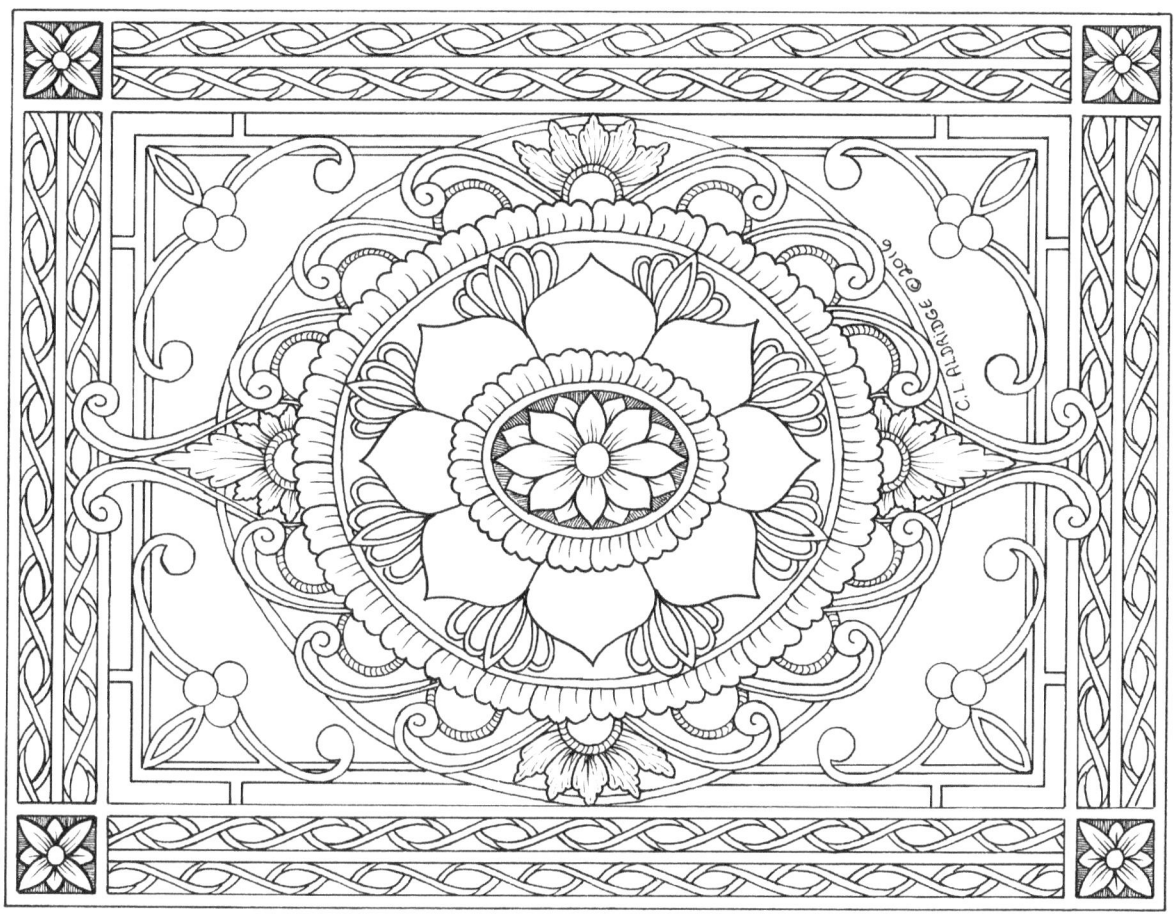

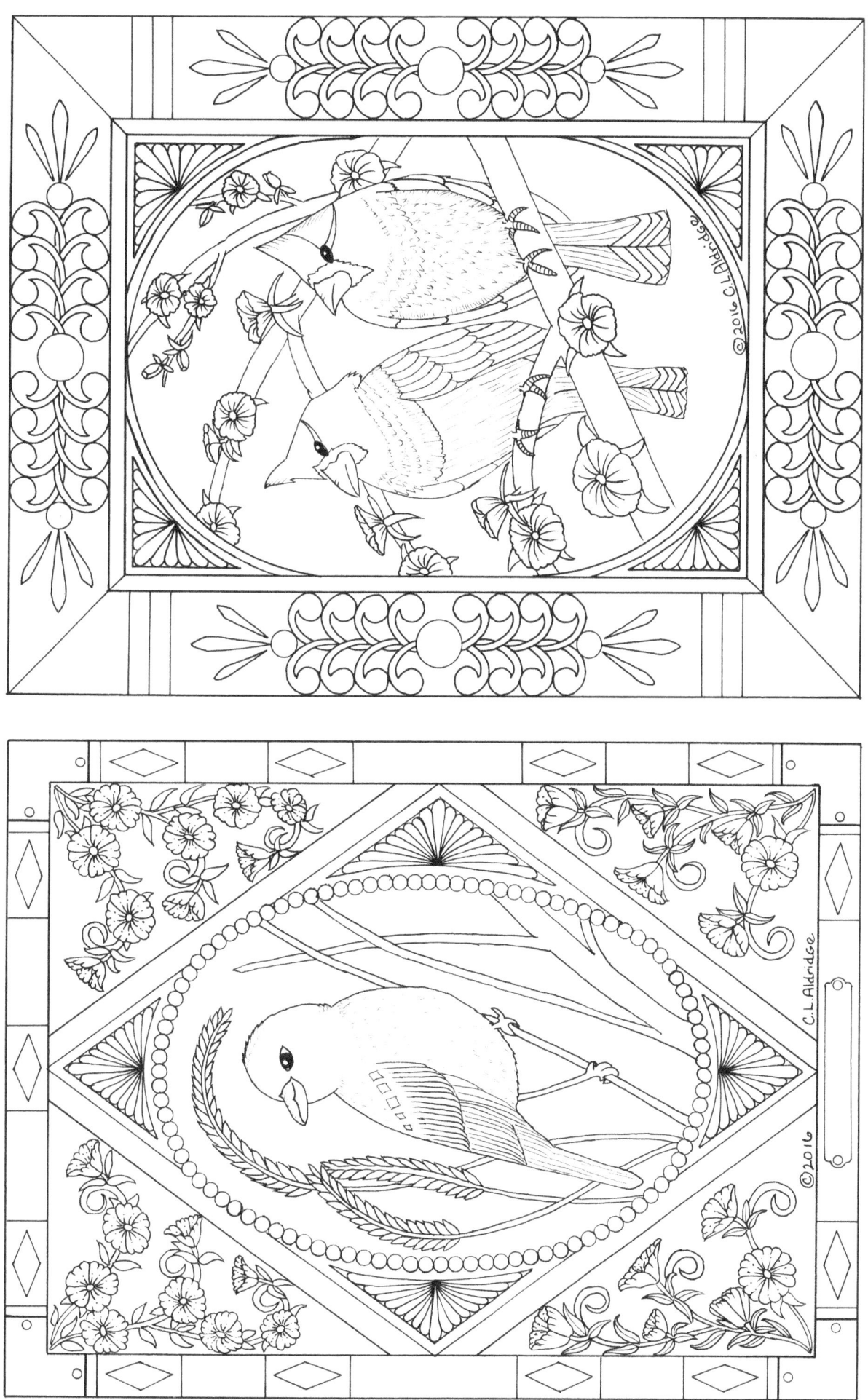

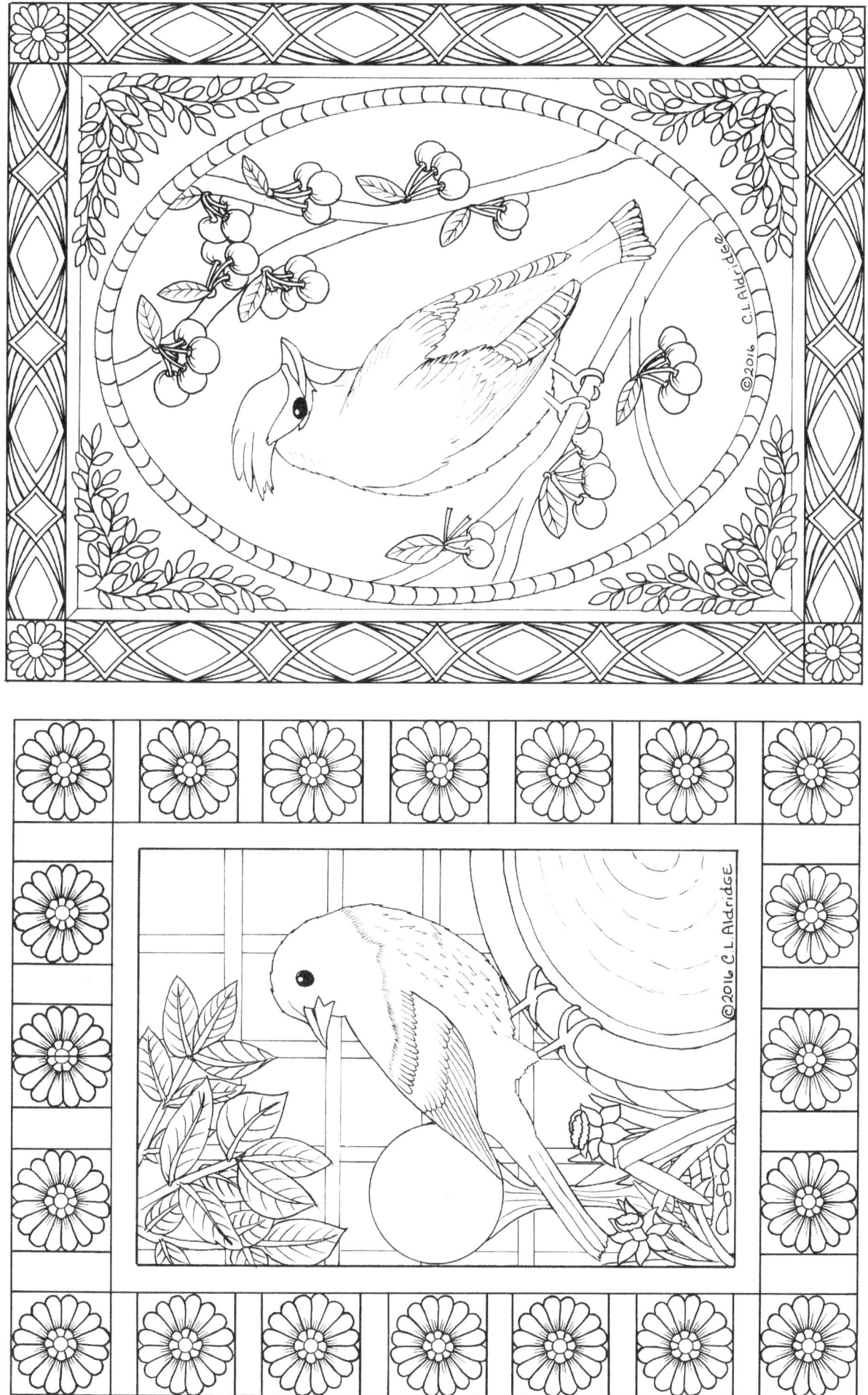

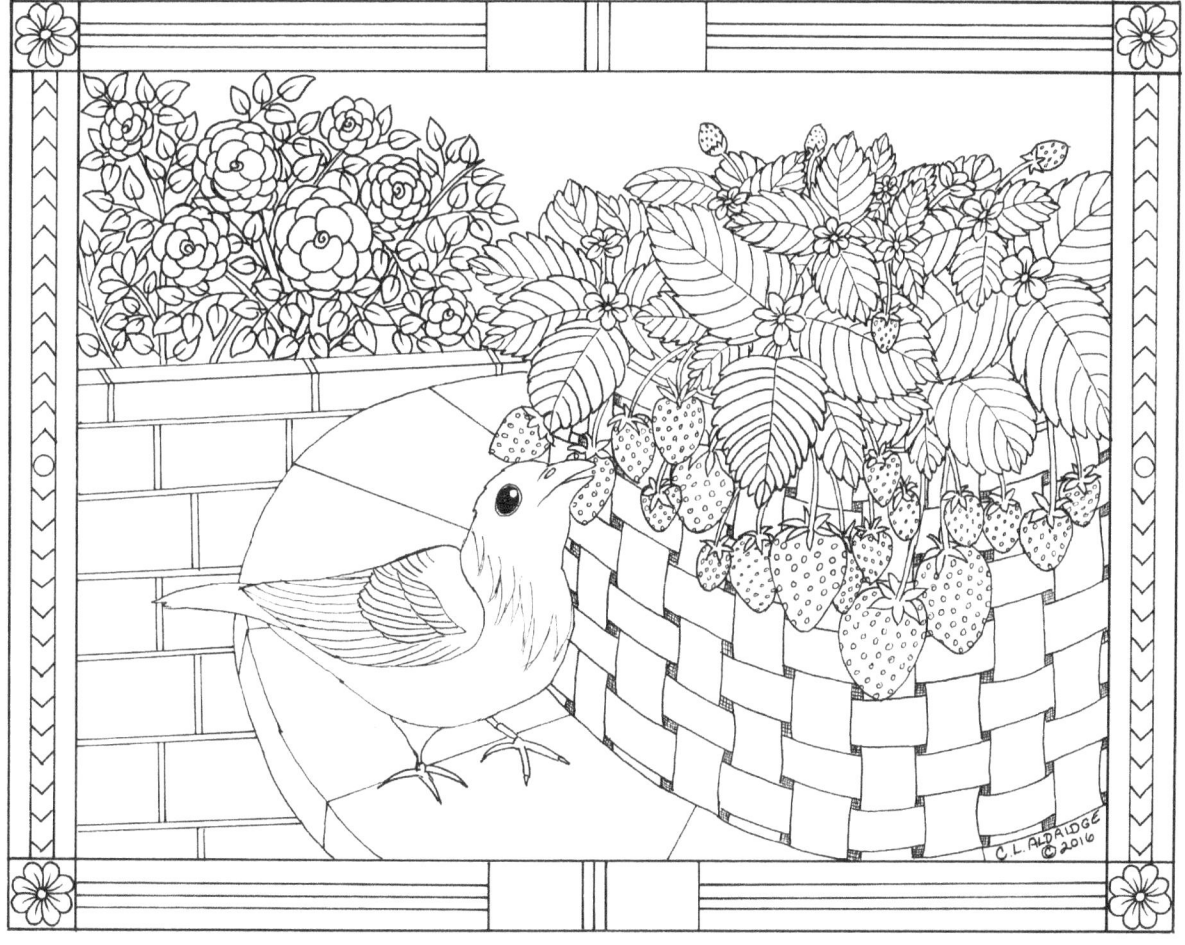

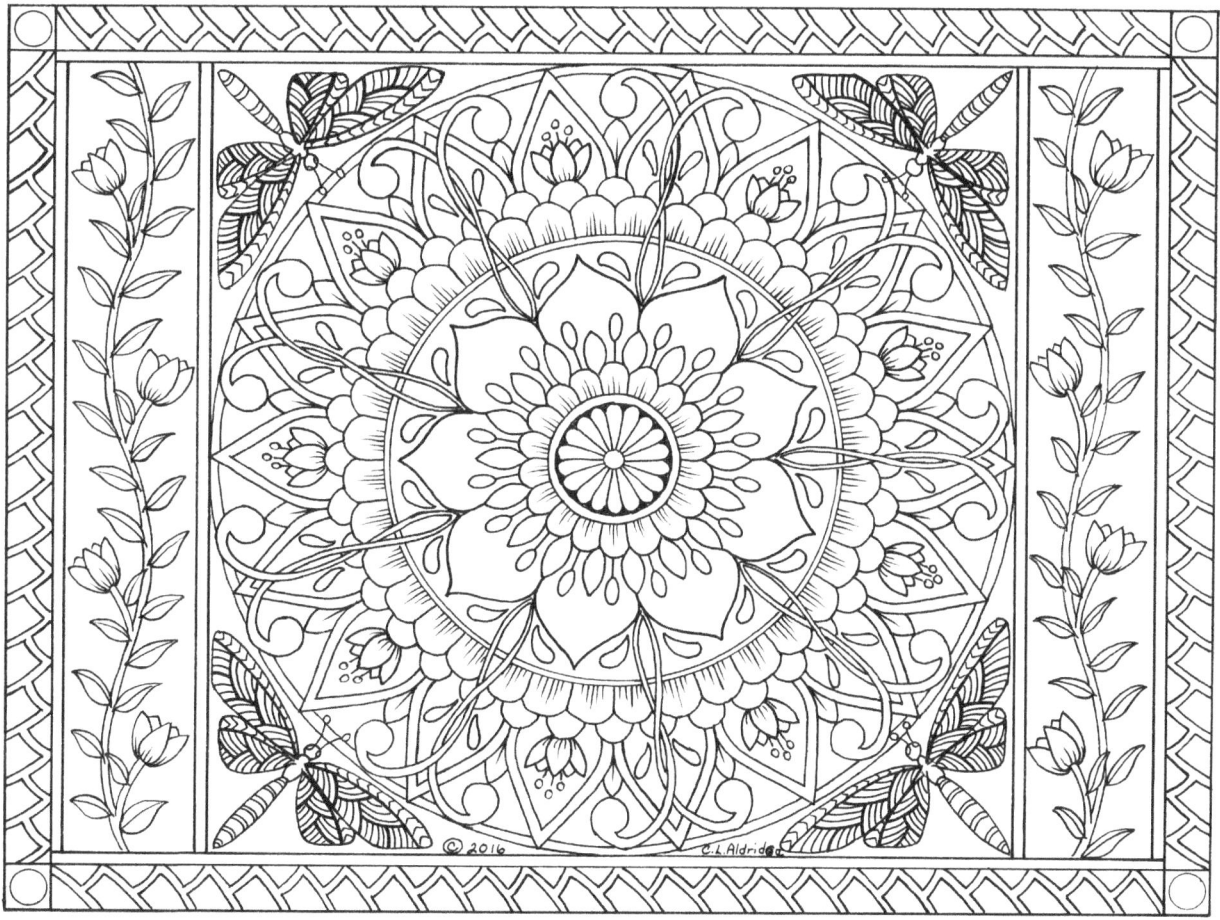

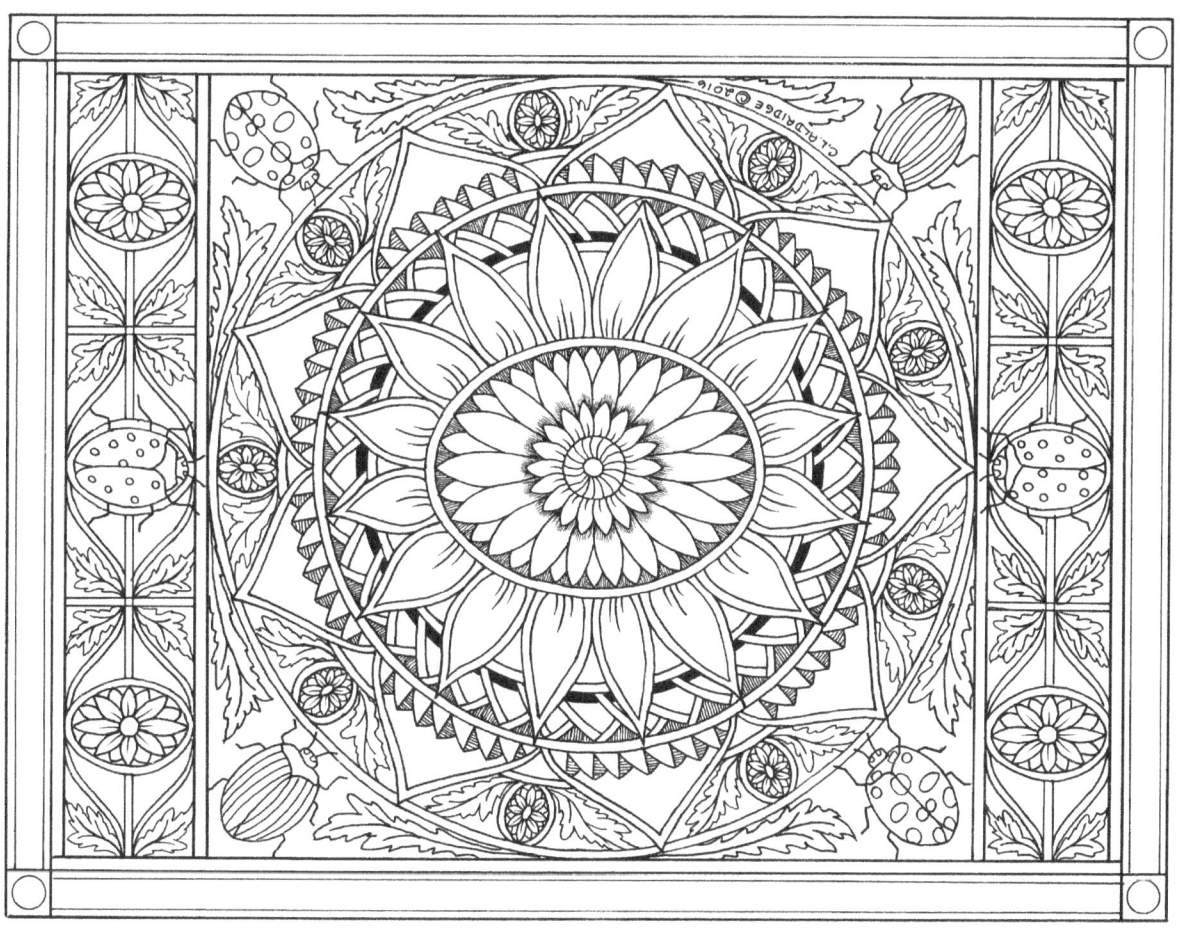

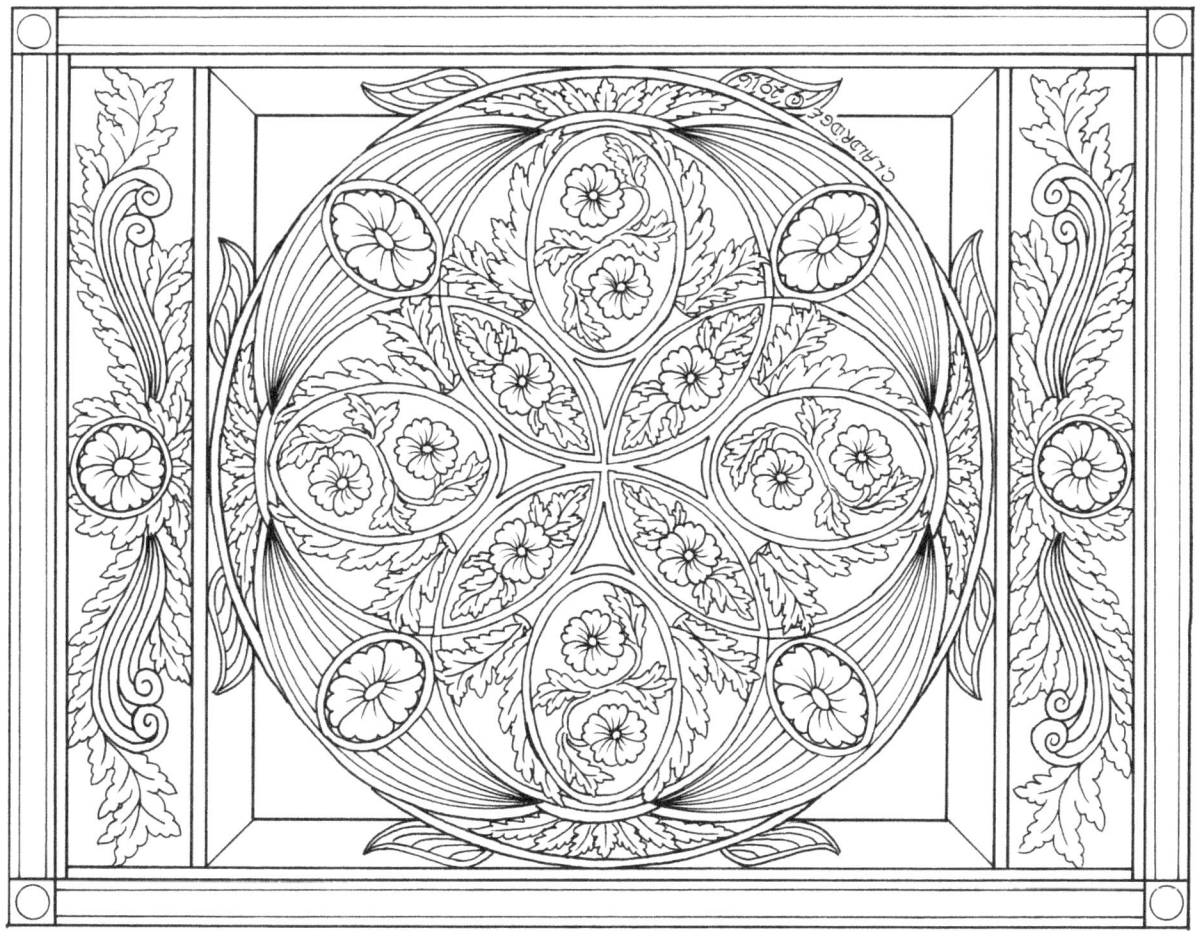

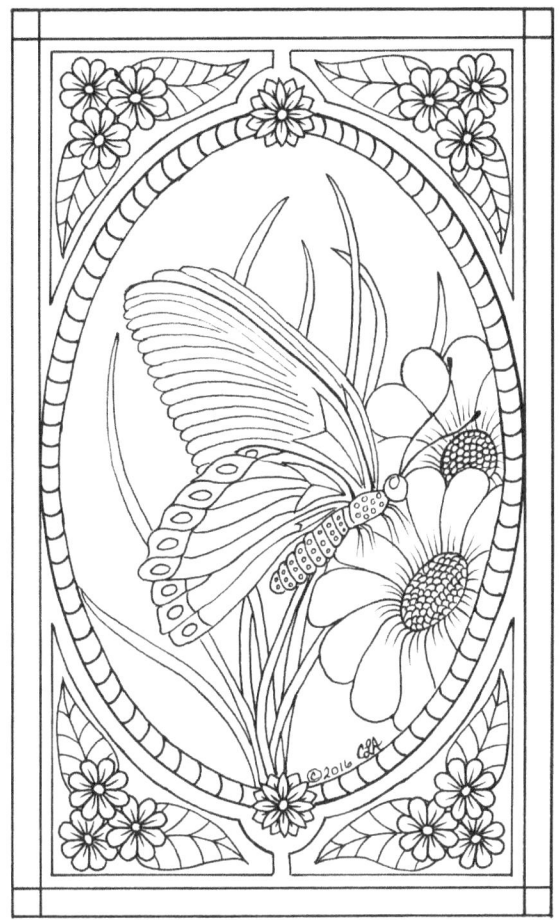
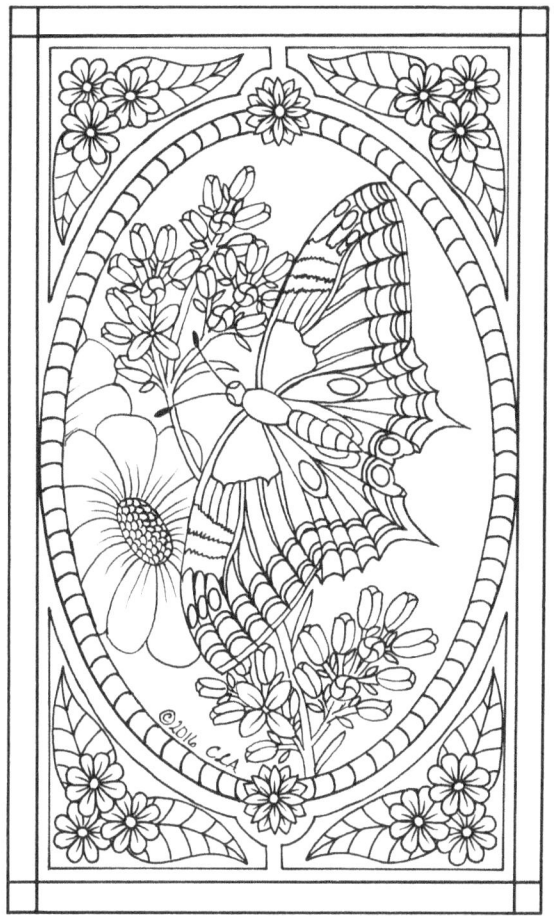
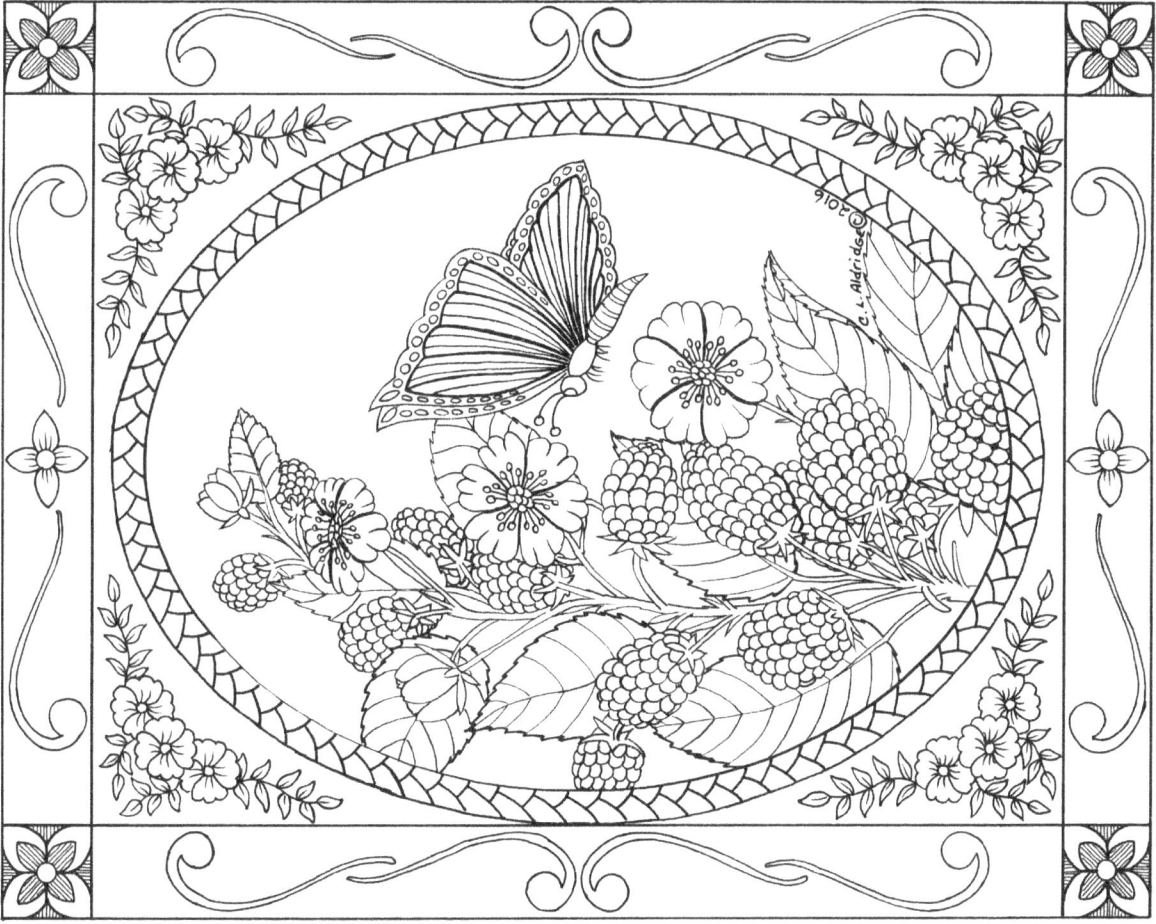

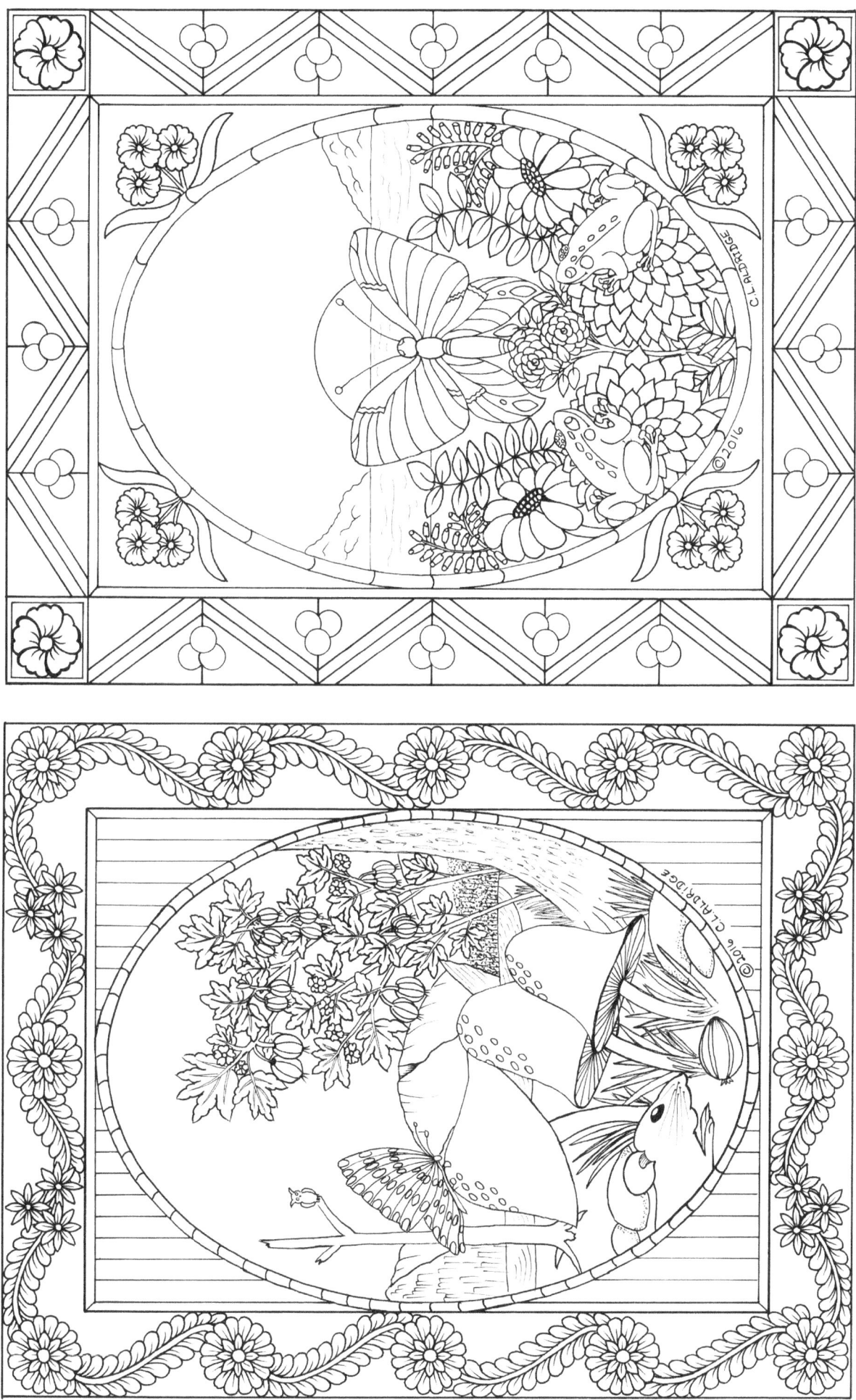

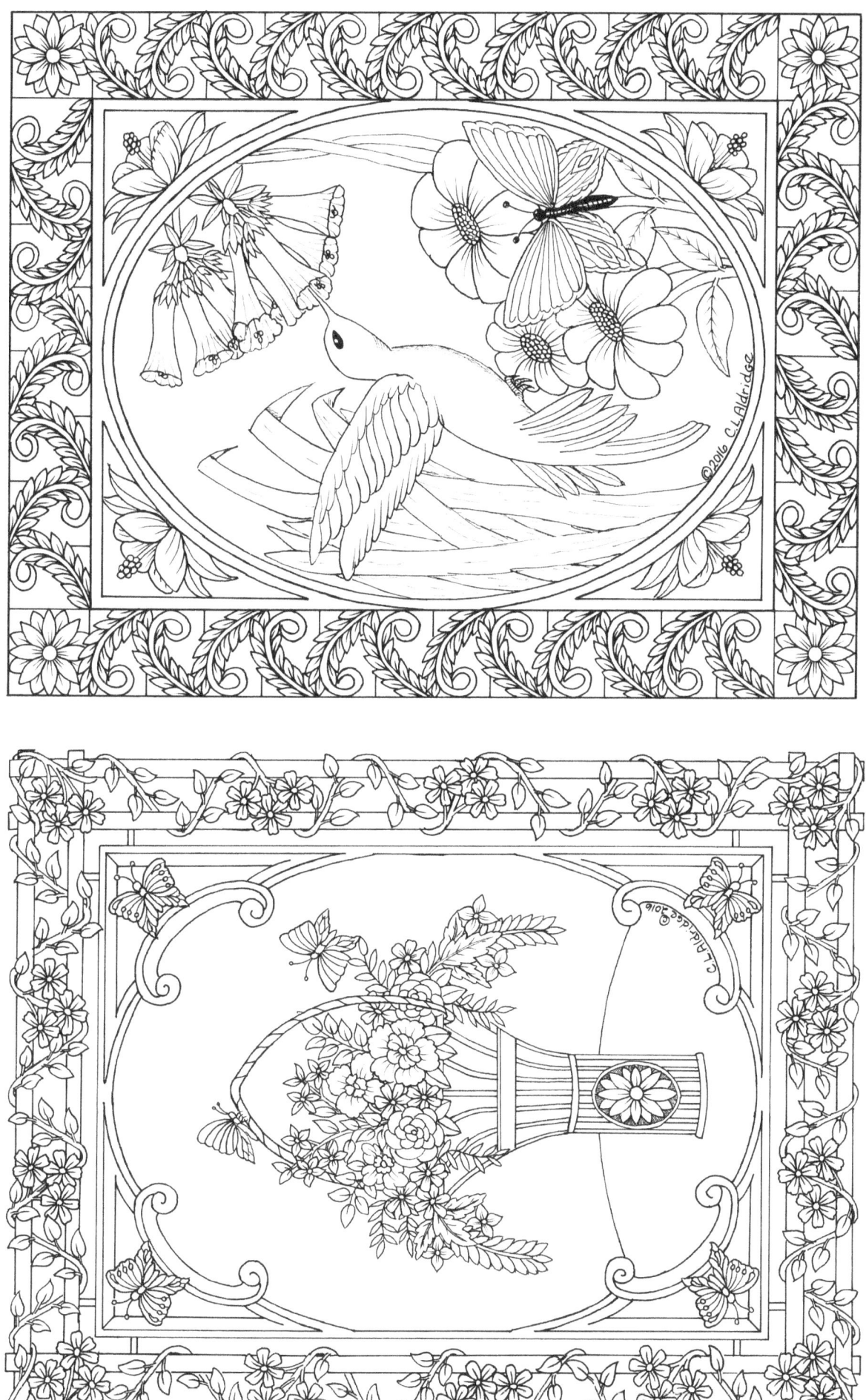

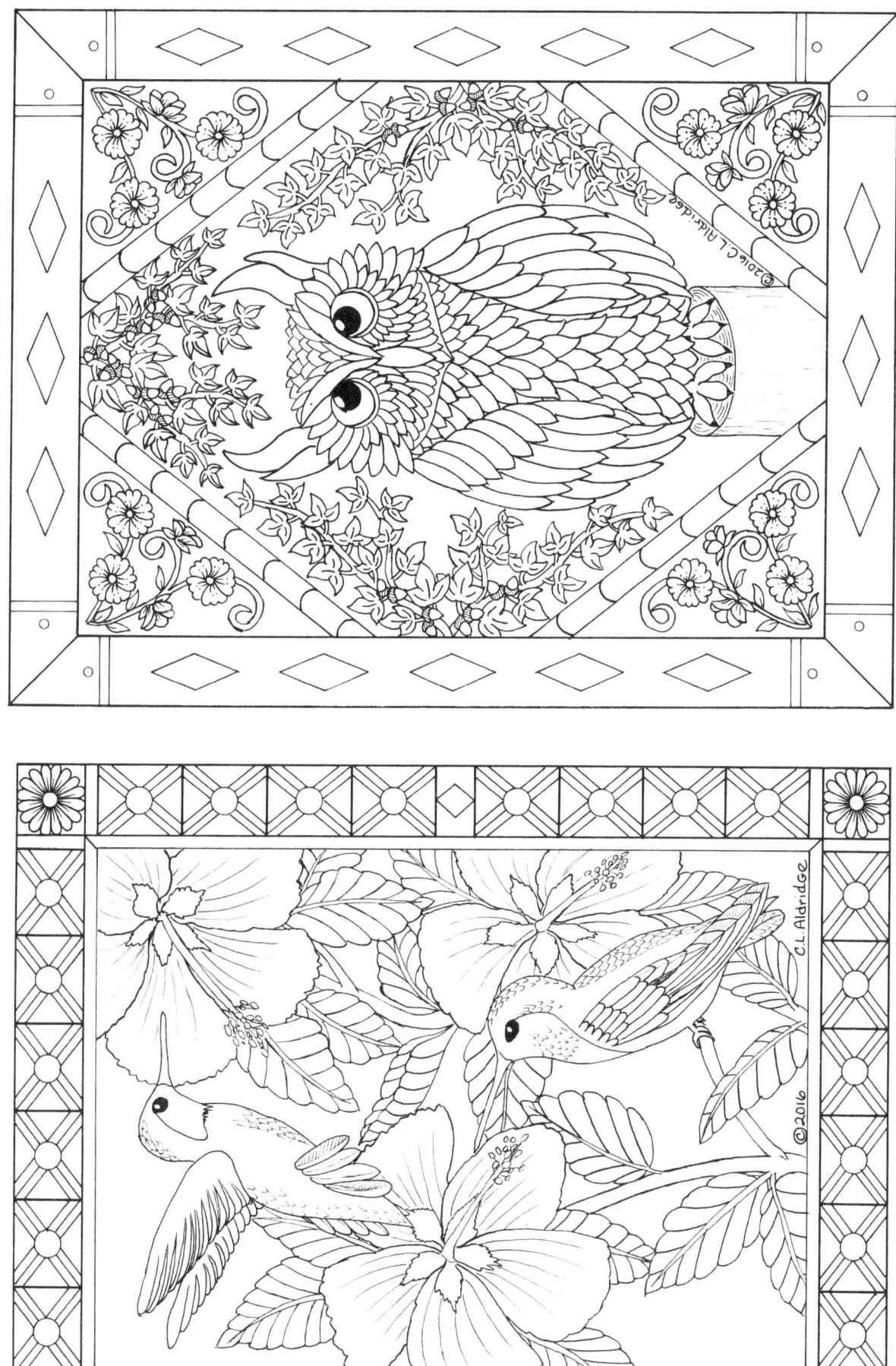

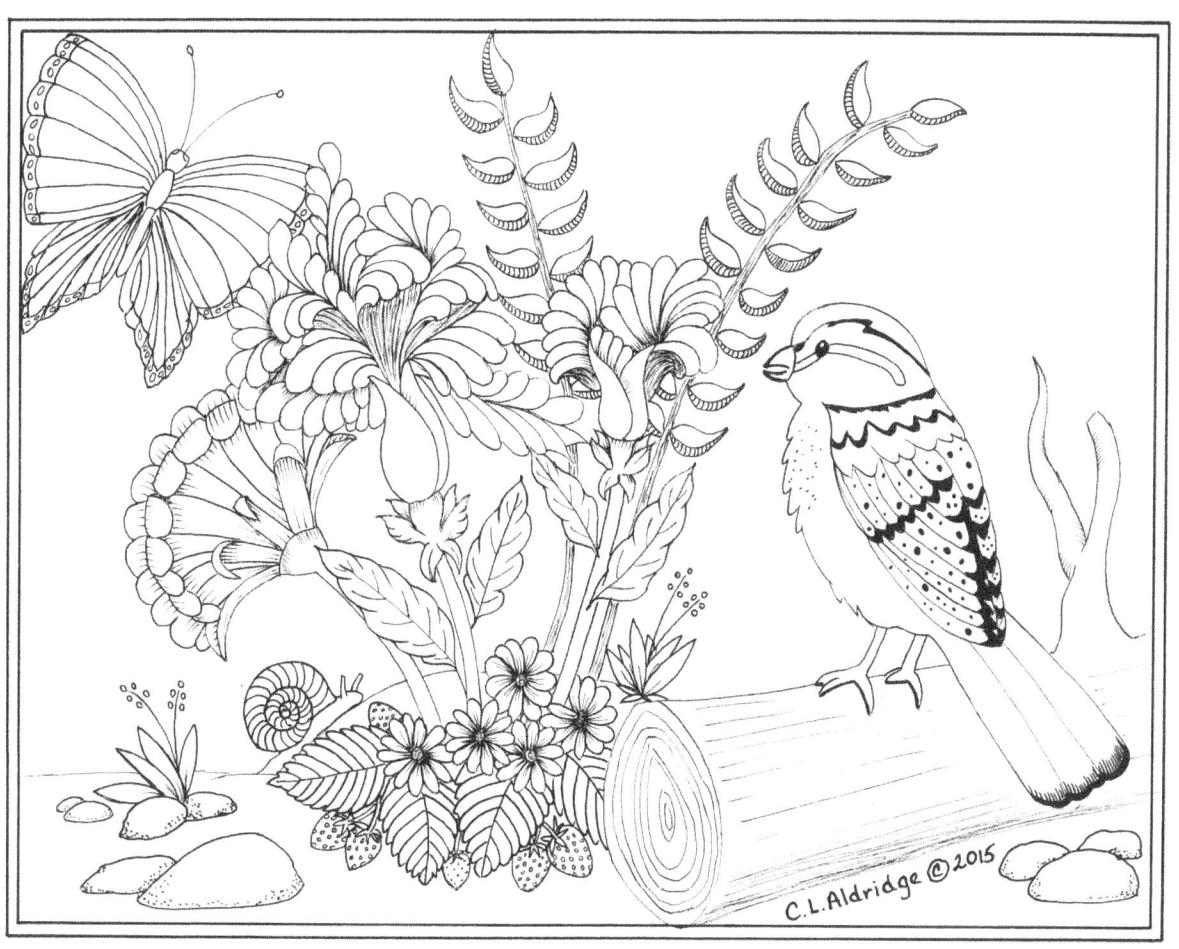

This page has intentionally been left blank for use as either a blotting page or color testing page.

This page has intentionally been left blank for use as either
a blotting page or color testing page.

This page has intentionally been left blank for use as either a blotting page or color testing page.

Don't miss my other Books

For more information, visit me
On the Web at: www.CLAldridgeArt.com
On Facebook at: www.Facebook.com/CLAldridgeArt
My Digital Site at: www.Etsy.com/Shop/CLAldridgeArt
Follow me on Instagram: @CLAldridgeArt

www.ingramcontent.com/pod-product-compliance
Lightning Source LLC
Chambersburg PA
CBHW080718190526
45169CB00006B/2422